Dutch Church Painters

Saenredam's *Great Church at Haarlem* in context

National Gallery of Scotland

6 July–9 September 1984

National Galleries of Scotland, Edinburgh

Festival of Architecture

The exhibition is made possible by the generous support of The Scottish Investment Trust PLC

Foreword

In 1982 the National Gallery of Scotland acquired a seventeenth-century Dutch masterpiece which is one of the most important pictures ever to enter the collection: Saenredam's *Interior of St Bavo's Church, called the 'Grote Kerk', Haarlem*. The artist is not a household name to those who visit art galleries and at the time of acquisition many asked, quite reasonably, who is Saenredam and why spend £1.4m on a picture by him? An attempt is made in the present exhibition to answer these questions, first by presenting a survey of Dutch church painting which shows where Saenredam comes in its development; and secondly by investigating this particular picture and its related drawings in an attempt to answer the further question, how did Saenredam do it? What rules of perspective did he follow, and to what extent did he manipulate them in order to create a construction of such sophistication and subtlety, and on such a tremendous scale? Saenredam's treatment of space has intrigued many people, and a number of theories have been advanced to explain the nature of his achievement. Our investigation of the Edinburgh picture has produced some positive results. By over-laying a drawing of the same elevation based on actual measurement, we are able to prove not only that Saenredam relied on surveyed data, but are able to indicate quite accurately those areas of the painting where the artist has manipulated the architecture for visual effect. Part of his construction drawing still survives and an investigation of this and also of the under-drawing on the panel, revealed by infra-red reflectography, further contributes to our knowledge of Saenredam's method of working. By a happy coincidence the facts to guide us to these conclusions and the right people to interpret them were at hand. Messrs H. W. van Kempen and G. Lankhorst, the architects advising on the restoration of St Bavo's, kindly sent us copies of their drawings of the church. Based on these, Mr Mahdad Saniee made a theoretical perspective of the same view of the interior as we see in the Edinburgh painting. We took advantage of Professor Martin Kemp's knowledge of optics and perspective to interpret Mr Saniee's projection, and also the reflectogram which had been taken by John Dick, the National Galleries' restorer. Any discussion of Saenredam to be worthwhile must be on his own terms. The resulting argument is bound to be complex and possibly difficult to follow. I therefore make no apology for this part of the exhibition, and have no hesitation in saying that Professor Kemp's essay is its most original contribution.

The introductory essay in this catalogue is intended for the general reader and depends largely on the published work of American art historians, in particular Arthur J. Wheelock, Timothy Trent Blade and Walter Liedtke. Much of the information on Saenredam is derived from the catalogue raisonné published at the time of the Utrecht exhibition in 1961. The English translations of the Dutch inscriptions are reprinted here by kind permission of the Director of the Centraal Museum, Dr A. M. Janssens. It seemed reasonable to include two pictures of secular buildings already in the collection, the Delen [11] and Houckgeest [33], although it must be stressed that this show is not a survey of Dutch architectural painting which to be comprehensive would require to include, for example, townscape pictures.

The great organ of St Bavo's, one of the most famous instruments in Europe at the time, figures prominently in the Edinburgh Saenredam. For this reason we invited Professor Peter Williams of Edinburgh University, an authority on the European organ, to write about it in the catalogue and also about the place of music in the Dutch Reformed Church. Music of Saenredam's period will be played on a tape at certain periods during the exhibition, thus providing the visitor with an authentic seventeenth-century sound.

This exhibition was originally intended to be smaller in scale and scope. At an early stage in its preparation however we were asked to take part in the Royal Incorporation of Architects in Scotland's Festival of Architecture. This show, expanded, seemed then the ideal contribution. That we were able to enlarge it is due to a generous subvention from The Scottish Investment Trust PLC. We wish to record our warmest thanks to Mr Angus Grossart, Chairman, and Mr Hamish Glen, Director and Manager, for their support.

The organiser of an exhibition of even this modest size incurs many obligations. Our thanks are due in particular to private owners: His Grace the Duke of Buccleuch; the Earl of Derby; the Marquis of Lothian; Mr Joseph Ritman and Mr Ian Woodner; and those other owners who wish to remain anonymous. For assistance in tracing pictures in private hands I wish to thank Mr Alan Jacobs; Mr T. S. Bathurst and Mr Adrian Eeles of David Carritt Ltd; Mr Richard Kingzett of Agnew's; Mr Ronald Cohen and Mr Alfred Cohen of the Trafalgar Galleries. I am particularly grateful to Mr A. D. N. Simonsz of the Royal Netherlands Embassy for much help and advice, not least in arranging for us to receive a generous cheque from Shell and negotiating support from the Dutch Government. My thanks are also due to Dr P. Biesboer of the Frans Halsmuseum, and Mr James Simpson of Simpson & Brown, Edinburgh. Finally, and more informally, I should like to thank Martin Kemp, Mahdad Saniee, Peter Williams and John Dick for the shared experience of studying this wonderful picture which all of us have found both rewarding and enjoyable.

Hugh Macandrew
Keeper

Introduction

In 1555, the seventeen Catholic provinces of the Netherlands (approximately the area of Benelux with a strip of northern France added) were inherited by Philip II of Spain from his father, the Emperor Charles V. By 1609, after many years of bitter struggle, seven of these provinces (of which Holland was the richest and most powerful) were Protestant and free from Spanish domination. The Sovereignty of the Dutch Republic was finally recognised by the Treaty of Münster in 1648. The Calvinists were the best organised of those who took part in the revolt against Spain. Of all the Protestant groups, they were the most militant and fanatical. They had established themselves in France by the middle of the sixteenth century and their influence spread north to the southern Netherlands, the Walloon provinces. They played an important part in the wave of iconoclasm that spread throughout the Netherlands in 1566, when serious damage was done to churches from Antwerp to Amsterdam. Paintings were burnt and many sculptures, altars, fonts, pulpits, organs and choir stalls were destroyed. And the Calvinists were the most significant element in the Sea Beggars, whose capture of the important seaports of Flushing and the Brill in 1572 signalled the real beginning of the revolt. Their influence spread rapidly in the northern Netherlands in the 1580s and '90s. Calvinism was a symbol of nationalism and its success was assured by the fact that it was anti-Spanish. It was inevitable, therefore, that when the split in the Netherlands finally came the division should be on religious grounds, with the dominating element in the north being Protestant and in the south Catholic.

After the Synod of Dort in 1618/19 the Reformed Church was defined according to strict Calvinist orthodoxy. It became much more difficult for the large Catholic population in the seven provinces to practise their faith, and many were dismissed from public office. No concessions were offered to them under the Treaty of Münster and no protection extended to them. Despite this however, there remained a strong element of toleration in the Republic and Catholics continued to practise their religion by whatever means possible. Among artists, Jan Steen and Jan van Goyen were Catholics, and Vermeer became one.

In the great debate about the place of images in Christian worship which gripped northern Europe in the early sixteenth century, the attitude of John Calvin (1509–64) was the most extreme. While admitting the dangers of images, Luther did allow that art had some place in church, especially in providing a narrative through illustration for the illiterate. Calvin believed, however, that there should be no ecclesiastical art. Religious images in any form encouraged superstition and idolatry, and where they existed they must be destroyed. The bare, whitewashed walls of the United Provinces, stripped of their decoration, altarpieces and statues, present a complete contrast to those of the Spanish Netherlands. Under the Archduke Albert and his wife Isabella, who enlisted the formidable intellectual might of the Jesuits, they became one of the centres of the Counter-Reformation. Church patronage revived in Antwerp after it surrendered to the Duke of Parma in 1585, but the real revival came when Spain signed the Twelve Years' Truce with the United Provinces of the Dutch Republic in 1609. In the Spanish Netherlands art was now put to the service of the Church Triumphant, and nowhere is the new spirit of Catholicism so brilliantly demonstrated as in the work of Rubens. New altarpieces were commissioned and altars, tabernacles, choir screens and tombs were introduced into Gothic churches [25, 26]. In the north however, they remained unadorned, although their vacant untrammelled spaces where windows let in clear daylight, to be reflected from white walls, were obviously an inspiration to artists like Saenredam and De Witte and the other painters who are the subject of this exhibition. No visitor to the recently restored New Church in Amsterdam can fail to appreciate the effect which these interiors of the Reformed Church must have had on those who dedicated much of their lives to painting them.

The precursors of Dutch church pictures of the seventeenth century are those architectural backgrounds which appear in certain religious pictures by fifteenth-century Flemish painters, among the most famous being Jan van Eyck's *Madonna in a Church* at Berlin, and Roger van der Weyden's altarpiece of the *Seven Sacraments*, Antwerp. The architecture in these pictures has a symbolic function which is complementary but subservient to the sacred theme occupying the foreground. The emergence of the subject as a specialist branch of painting, and one worthy of treatment in its own right, occurs in Antwerp in the later sixteenth century. One of the most important figures in its development was Jan Vredeman de Vries (1527–c. 1604). He trained as a painter and worked as an architect, but his pictures are rare and no buildings by him have survived. Today he is best remembered for his prints in which he displayed an astonishing range of invention both in ornament and architecture. His best known prints are those contained in his *Perspective* (1604/05) which made his northern contemporaries and followers aware of the sophisticated methods of the Italians in this subject, particularly those of Serlio, but also of Dürer. There was a substantial body of perspective literature in northern Europe by 1600, but the plates in De Vries's volume [1], mostly of architectural fantasies, remained a rich source of inspiration for the artist producing both secular and religious pictures, and were freely plundered for ideas.

Perspective is a method of conveying an illusion of the third dimension on a flat surface. An artist whose main interest

was in the representation of space could only succeed if he was properly grounded in the laws of perspective, and the Dutch church painters of the seventeenth century showed that they were. The fact that temple or church interiors are described in seventeenth-century Dutch and English inventories as 'perspectives' is an indication of how contemporaries regarded examples of this genre. For example, there were four pictures by Houckgeest described as 'prosspectives' in Charles I's collection. And it is interesting to observe that in addition to the palette and brushes which she holds in her left hand, the allegorical figure of Painting in the frontispiece to the 1662 edition of Marolois's treatise supports by her side a picture of a vaulted loggia in perspective [8].

The perspective system that had the greatest influence in European art was that evolved in Florence in the early fifteenth century, where there developed the idea of the picture as a view through a window, a transparent plane intersecting a visual pyramid – its apex being the viewer's eye, its base the object observed. Such a notion of painting, quite alien to the painter of gold ground pictures, which deny real space, held sway in European art until the end of the nineteenth century. Scientific or linear perspective was discovered (or rediscovered) about 1413 by the architect Brunelleschi, who designed the dome of Florence Cathedral. He developed a technique for portraying buildings in accurate perspective, a system which implied a fixed viewpoint and required the spectator's eye to remain static. Brunelleschi's ideas were developed by his friend Leon Battista Alberti, whose treatise *On Painting* (1435 / 36) contained the first published perspective construction, and describes the method to be used by painters for projecting mathematically the third dimension on a flat surface. He demonstrated that the parallel edges of objects stretching away from the spectator's eye converge on the horizon at an infinite point, later to be called the vanishing point. Many of the pictures in this exhibition, most obviously those by the Steenwycks [4–7] and Neeffs [9] were constructed according to the system of linear perspective evolved by Brunelleschi and Alberti; and Saenredam in the fragments of his construction drawing for the Edinburgh picture, followed the basic principles they established.

The influence of Vredeman de Vries may be seen in the pictures of the Steenwycks, father and son, who were among the first painters to specialise in architecture. Their pictures may be regarded as translations into paint of certain favourite themes in Dr Vries's prints; the fanciful terrace view, for example [2], or the vaulted interior [1]. Their paintings invariably illustrate some subject, either sacred or profane, but the people in them are dominated by their architectural setting which was clearly the principal interest of the artist. If, for example, St Jerome in either of the two pictures by the younger Steenwyck shown here [6 and 7] is compared with the engraving by Goltzius [3], or with the Dürer engraving [fig. 1] which clearly inspired it, it will be seen that the holy figure with his minuscule lion in the former has shrunk in relation to his surroundings and is dominated by the room in which he sits.

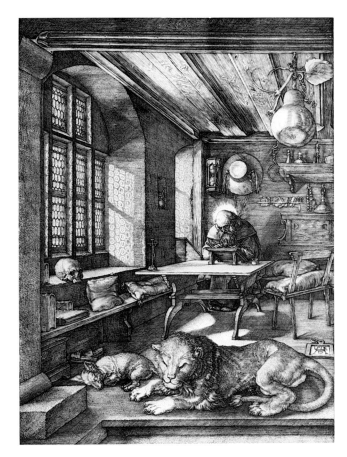

[Fig. 1] Dürer, ST JEROME IN HIS STUDY. Engraving 1514. National Galleries of Scotland

The younger Steenwyck came to London and remarked on the disadvantages of being an architectural painter to his friend Edward Norgate, who wrote: 'The only Inconvenience incident to Perspective, and whereof I have heard Mr Steinwicke complaine with indignation, was that so many were the lines perpendicular parralell and the rest, that another Painter could compleate a peece, and get his money, before he could draw his Lines.'* Examine any Steenwyck in a raking light and you will appreciate exactly what Norgate says.

Architectural painting, having been established, was now adopted as a specialist activity by certain families and their studios, the most famous being the Neeffs from Antwerp. Pieter Neeffs the Elder (1578–c. 1659) was greatly influenced by the Steenwycks. His approach to paintings was, like theirs, essentially a linear one and the style of the buildings he painted invariably Gothic. Like the Steenwycks and other architectural painters of the period he collaborated with artists who were specialist figure painters, in Neeffs's case Frans Francken II and Frans Francken III. One of Neeffs's most popular compositions was a view of the interior of Antwerp Cathedral, and the many versions of this which still survive were no doubt produced by Neeffs or his studio for those who wished to have a souvenir of the recently refurbished interior. The picture included in the exhibition [9] may be taken as a conventional church interior

* *Miniatura or The Art of Limning*, ed. M. Hardie, 1919, pp. 86–7.

of the period – a view of the nave, popularised by De Vries, allowing the artist full scope to show off his grasp of linear perspective. It conveys the impression that the front of the building has been removed and that the spectator is looking in at it from a position high up and outside it. A rare drawing of the Münster at Bonn (1618) in the Lugt Collection, Paris, is proof that Pieter Neeffs made drawings of actual buildings on the spot, and no doubt the view of Antwerp Cathedral ultimately depends on some such record. But here the connection with reality is tenuous and there is no sense of atmosphere. The way in which the vault of the nave has been painted, for example, has become a trick and the choice of colours a convention.

The traditions and practices of the Antwerp painters were continued by the first generation of Dutch artists to specialise in architecture, for example, Dirck van Delen (1604/5 –71) and Bartholomeus van Bassen (d. 1652). That the latter did paint real church interiors is proved by his view of the Cunerakerk, Rhenen, in the National Gallery, London.* The painting shown here [14], containing an odd jumble of Gothic and Renaissance motifs, is however more typical of his work, and it is in opposition to this tradition of fantasy in architectural painting that one should view the work of Pieter Saenredam.

SAENREDAM

The recorded facts of Saenredam's life are few, but there may never have been much to know about a life that, outwardly at least, appears so uneventful. The still centre in his pictures speaks of intense study and obsessive concentration, and it can perhaps be said of Saenredam more than many artists that his life was his work and that there is very little else we need to know. Two facts, however, are significant. Although he spent ten formative years with the figure and portrait painter Frans Pieter de Grebber it was in the graphic tradition of his father, the engraver Jan Saenredam (a pupil of Goltzius), that his art has its origin. The other point of significance is that he was a close friend of a fellow pupil in De Grebber's studio, the great Dutch architect Jacob van Campen, with whom he collaborated in later life and from whom he may have derived much of his knowledge and understanding of architecture.

How original was Saenredam's contribution to Dutch church painting, and what is the nature of his achievement? Although neither the first to paint real interiors (there is a view of Aachen Cathedral by the elder Steenwyck), nor to draw them on the spot, Saenredam did reject outright the element of fantasy that had characterised so much contemporary architectural painting and concentrated exclusively on drawing and painting actual buildings. His sole preoccupation was with the precise recording of observed reality, a conscious choice he was at pains to underline when he inscribed certain drawings 'naer het leven' ('from life')†– for

example, the drawing now at Haarlem which is a preliminary study for the print in Ampzing's book [16]; and that of St John's Church, 's Hertogenbosch [25]. The consequence of this for Saenredam was that in his drawings and paintings he adhered to his actual viewpoint, i.e. the position he adopted while standing in a church, which was no longer high up and distant as in Neeffs for example. And he introduced a whole range of new views in contrast to the conventional nave view of earlier and contemporary painters.

Saenredam's obsession with reality was combined with a strong antiquarian interest. It is obvious that he was keenly aware of different styles in architecture – Romanesque, Gothic, Renaissance. Early wall paintings, medieval stained glass and old funerary monuments are accurately recorded. For example, so meticulous is his copy of the right shutter by Vrederick Hoon (c. 1430–1505) of the organ in St Bavo's [fig. 15] that this detail is precious evidence of a period in Haarlem painting of which little has survived. He was also interested in armorial bearings, which even within the limits of a sketch are easily identifiable.

This precision extended to Saenredam's practice of inscribing many of his paintings and drawings with the precise date on which he began them and also the date of completion; and frequently in the case of the drawings a reference is made to the related painting.

Saenredam was above all a draughtsman and a proper understanding of his art is only possible through his drawings, of which there are two kinds: the freehand sketch done on the spot and, deriving from this, an elaborate construction drawing prepared for a specific picture. Saenredam's freehand drawings are in a variety of media: black chalk on pale blue, buff or grey paper, with the source of light indicated in white; or a combination of pen and ink; chalk and watercolour elaborately worked together, which one sees to best advantage perhaps in the series of drawings he did of Utrecht churches in 1636. Today they are preserved in the City Archives and must count among the most beautiful architectural drawings in European art.

Before starting his sketch Saenredam invariably fixed the 'eye-point' or point of sight (indicated thus ⊙, and sometimes inscribed oog = eye).* Although he sometimes drew in the main perspective lines Saenredam never felt bound by them. He allowed his eye to wander unconstricted by the vanishing point. These freehand drawings convey a wonderful sense of place which transcends mere topographical accuracy. The Edinburgh drawing of St Mary's Church, Utrecht [27], for example, makes one aware of the building's unevenness and antiquity, but also conveys something of the sensation of being there. These on-the-spot drawings are Saenredam's personal record of his sketching tours to various towns in the Netherlands. They were done with no particular painting in mind, and in certain cases many years separate sketch and the picture deriving from it.

* W. A. Liedtke, *Architectural Painting in Delft*, 1982, p. 23, pl. III.
† There is an illuminating discussion of this term in D. Freedberg, *Dutch Landscape Prints*, 1980, pp. 10–11.

* The 'eye-point' = that point where the visual rays from the artist's eye first touch the picture surface, and in a centric system of perspective corresponds to the vanishing point.

Before starting a painting Saenredam would make a construction drawing [19 and 20] based on the earlier sketch and incorporating the same 'eye-point' [18]. The purpose of such drawings was utilitarian: to produce an exact outline of the painting, based on actual measurement and constructed according to the rules of linear perspective. Human figures are introduced (and blotted out) as modules to establish correct proportions. Many of these drawings, executed in pen and ink and grey wash, were made to the size of the painting; their ruled outlines (in the case of most cabinet-size pictures) transferred by the process of blacking the reverse of the sheet which was thus used like a piece of carbon paper.

Saenredam's paintings are portraits of individual buildings, which are not only accurate records of what they looked like, but which convey to the spectator in some mysterious way their unique spirit. The vividness of direct contact which is so much a feature of the freehand sketch is recaptured in the painting, but the sensation has been formalised. Each picture by Saenredam is also an abstract statement about space, and contains within it both the exposition of some problem as well as the visual demonstration of its resolution. To generalise therefore is impossible, because every picture must be treated separately and the only thing that each has in common is the artist's awareness that a painting is essentially a flat surface which any illusion of depth disrupts. That Saenredam was able, through an exquisite sense of surface pattern, to hold the two forces in balance is the ultimate mystery and fascination of his art.

PAINTERS IN DELFT

Saenredam stands apart in the history of Dutch church painting. He had no pupils and no real followers, although it has been suggested that he was the catalyst for certain painters living in Delft whose contribution to the genre, aside from Saenredam's, was the most original in its later development.

The pictures by Houckgeest [34] and De Witte [35] in the exhibition are fine examples of the new approach. An oblique view of some part of the church is glimpsed at through columns, reflecting the sunlight, which dominate the foreground. One or two vanishing points are employed and are placed either near the edge of the composition or off the picture altogether. The effect on the onlooker of this casual and informal approach is to draw him into the scene, which expands around him. The whole is enlivened by patches of sunshine and shadow and vivid accents of colour. It is now generally agreed that this new image of the church interior was introduced by Houckgeest about 1650, although it remains a mystery how and why he changed from being a painter of imaginary architecture to one specialising in real church interiors. A mere twelve years separate his *Architectural fantasy* of 1638 [33] and the *View of the New Church in Delft with the tomb of William the Silent* [fig. 2], dated 1650. How can we explain so sudden and radical a change in direction? The veneration for the tomb of William the Silent, following the death of Prince William II in 1650,

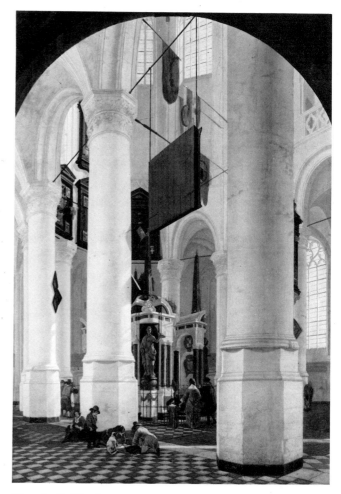

[Fig. 2] G. Houckgeest, NEW CHURCH IN DELFT WITH THE TOMB OF WILLIAM THE SILENT. 1650. Hamburg, Kunsthalle

may account for the demand at this time for pictures of the monument which are frequently the subject of the new view. And there must have been other paintings, now no longer surviving, which would have made the transition less abrupt. Nevertheless, the Hamburg picture remains one of the most original Dutch paintings of its kind.

The Delft type of church view was continued in the work of Hendrick van Vliet [38], although its period of greatest originality was short-lived. By 1652 both Houckgeest and Emanuel de Witte had left Delft, the latter to settle in Amsterdam.

De Witte is one of the greatest Dutch artists of the period and was more than a painter of church interiors. He produced figure subjects throughout his life and one of his best is the charming family group now at Münich [fig. 3]. A prosperous couple with their little daughter are shown in a richly furnished room, on one wall of which hangs a De Witte church interior. As we know from Ampzing's panegyric on Haarlem [16] the local church was a source of local and civic pride, and no doubt it is the family's church that is depicted in the De Witte, with themselves portrayed in it. Figures are an important element in De Witte's earliest surviving church interior, that of the *Old Church in Delft* of 1651 (Wallace Collection), as indeed they are in all his church pictures. In this he is unlike Saenredam, although the

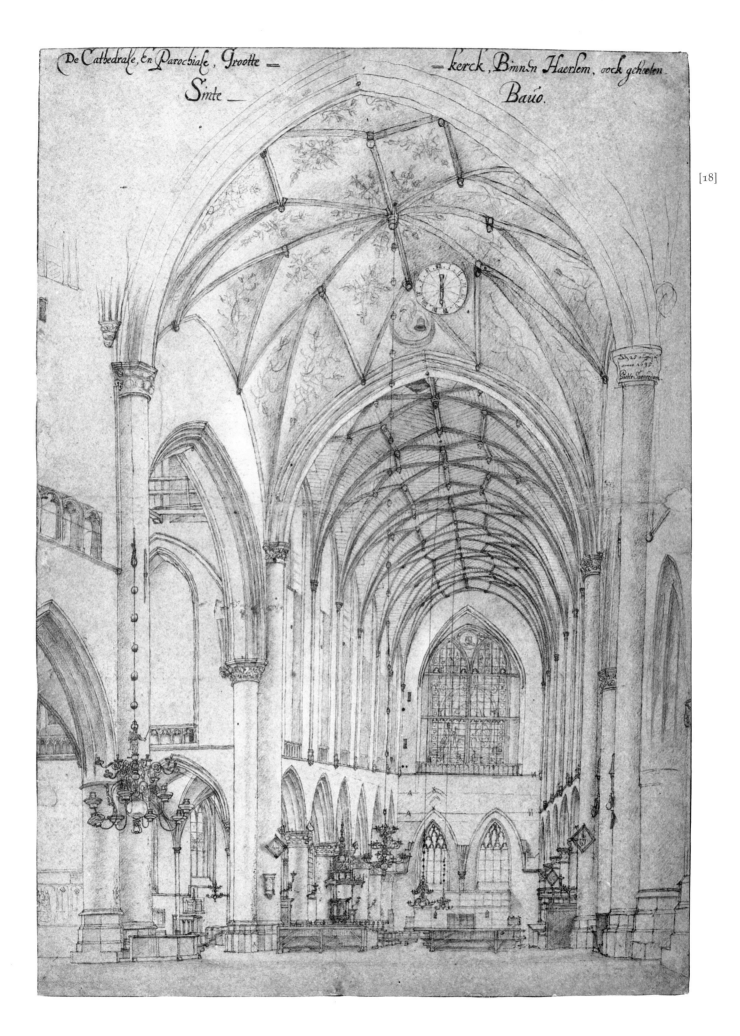

De Cathedrale, En Parochiale, Grootte — — kerck, Bmnen Haerlem, oock geheeten
Smte — Bauo.

[Fig. 4]

[Fig. 5]

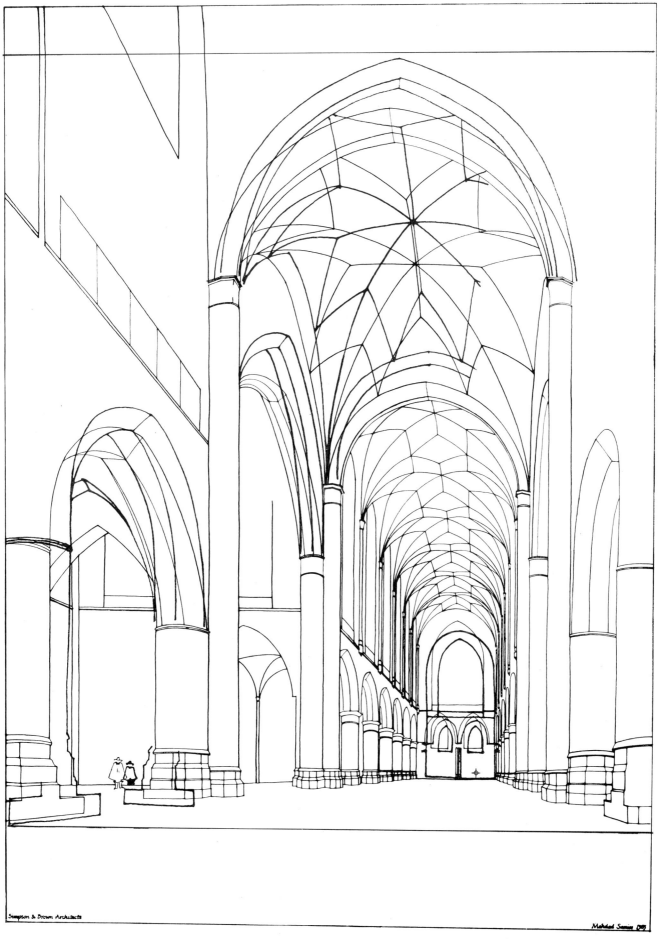

Simpson & Brown Architects

Mahdad Samimi 1989

[Fig. 4] THEORETICAL PERSPECTIVE OF THE INTERIOR OF ST BAVO'S (*page 24*) by Madhad Saniee (of Simpson & Brown, Architects, Edinburgh).

Based on measured drawings supplied by H. W. van Kempen and G. Lankhorst.

[Fig. 5] THE THEORETICAL PERSPECTIVE [fig. 4] AND THE PROJECTION IN THE EDINBURGH PAINTING COMPARED (*page 25*)

This diagram was produced by overlaying a tracing of Saenredam's composition on the theoretical perspective [fig. 4] to discover the extent to which the two differ, and where. The red lines indicate the main areas in the painting where the artist has manipulated the architecture to produce the visual effect he desired.

[19] INTERIOR OF ST BAVO'S: VIEW OF THE SOUTH TRANSEPT

Pen and ink and grey wash over graphite, on four sheets of paper joined together. There are red lines ruled horizontally appr. 13cm from the top and 18cm from the bottom; and one ruled vertically, appr. 18cm from the left margin. 48.9 × 35.6cm

Inscribed by the artist at the base of the column, lower left: *Dit geeijndicht met teijckenen/den 15 december 1635. ende is/een gesicht inde grote kerck binnen/Haerlem met schilderen volei-jndicht den 27 februarij 1648* (finished drawing this the 15th of December 1635 and is a view in Great Church in Haarlem finished painting the 27th February 1648). Below this, another inscription also in the artist's hand: *Het paneel daer dese ordonnantij / op geschildert staet is breet / vijff voet en 2 duijmen / ende is hoogh / 6 voet ende 3 duijmen. naer kermer / ofte kennemer voetmaet.* (The panel on which this construction was painted is five feet and 2 inches wide and 6 feet and 3 inches high, after 'kermer' or 'kennemer' footmeasurement.) To the right of this: *30*, below which is a small circle bisected.

This is the lower left portion of the dismembered construction drawing (fig. 7).

Exh: Utrecht 1961, no. 60, pl. 62

Gemeentearchief, Haarlem

[20] INTERIOR OF ST BAVO'S: VIEW OF THE NAVE AND WEST END (colour plate, page 28)

Pen and brown ink and grey wash over graphite, on two sheets of paper joined horizontally. Ruled lines in red chalk at both the top and bottom of the sheet correspond with those on the previous drawing; another is ruled vertically appr. 17.5cm from left margin. The 'eye-point' is indicated lower right of centre; 49 × 35.7cm.

The lower right-hand portion of the dismembered construction drawing [fig. 7].

Exh: Utrecht 1961, no. 61, pl. 63; *Master Drawings from the Woodner Collection* (Catalogue by George R. Goldner), Malibu, Fort Worth and Washington, 1983 / 84, no. 51, repr.

Ian Woodner Family Collection

[Fig. 6] THE GRAPHITE PERSPECTIVE CONSTRUCTION IN THE WOODNER DRAWING [20] (*page 29*).

This records only those lines which can be traced directly from a colour facsimile, and should not be regarded as a complete record. Important lines are likely to be obscured by the overlying pen and wash drawing.

C	vertical line marking central axis of the end wall
D/D	lines running from diagonally opposite capitals of crossing
E	'eye-point'
H	horizon line
O/O	etc – centres of semicircular arcs from which the vault is constructed
R	lines in reddish chalk
J	join in the sheets of paper

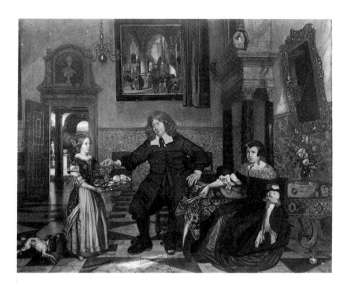

[Fig. 3] E. de Witte, FAMILY GROUP. 1678.
Münich, Alte Pinakothek

differences between the two are more fundamental. Saenredam's approach was that of the draughtsman, De Witte's that of the intuitive painter who opposed the linear. The latter was interested in textures, and the drama of light and shade, and many of his later pictures, certainly, must have been conceived directly onto the canvas with little reference to preparatory drawings.

De Witte eventually abandoned the oblique view which had been developed in Delft and became less interested in any form of perspective projection. Increasingly he conceived his pictures in terms of surface pattern, like Saenredam, but, unlike him, expressed in painterly terms. A picture in the National Gallery in London [36] beautifully illustrates a stage in his development. It shares with earlier pictures the artist's mastery of sunlight, which illuminates some parts of the building and casts others into shadow. The architecture, however, is placed parallel to the picture plane and the sense of recession is minimal. Figures and objects in the foreground are nicely calculated to impinge on the background at key points, and always the artist stresses the integrity of the surface. At the end of his life he became less interested in producing views of actual buildings, and many of his latest paintings are fantasies [37], combining elements of the Old Church and New Church in Amsterdam. In these imaginative recreations of reality, in which light and shade find their equivalent in patterns of oil paint, the Dutch church interior has come full circle.

Catalogue

[1]

Jan (or Hans) Vredeman de Vries, 1527–c. 1604

Painter, architect and engraver. Born in Leeuwaarden (Friesland) and lived for some time in Antwerp. He worked in Germany and also at the court of the Emperor Rudolph II at Prague.

[1] PERSPECTIVE (The Hague and Leiden, 1604–05), Part I, plate 47.

Subtitled the 'most famous art of eyesight' and dedicated to Prince Maurice of Nassau, it was published in two parts: the first containing 49 plates, the second 24. This collection is part practical manual, part source book for imaginary compositions. The most popular with painters were those depicting the vaulted interiors of churches; or ones with terraces and colonnades with views of fantastic palaces in the distance – such as in the following plate [2].

The British Library

[2] (PERSPECTIVE, Part II, plate 9.)

This plate was republished by Samuel Marolois in *Perspectiva theoretica ac practica . . .* (Amsterdam, 1633). The palace views of Dirck van Delen [11] were among the many pictures inspired by De Vries's prints.

Newbattle Collection. The property of the Trustees of the National Library of Scotland, at present in the custody of the Marquis of Lothian.

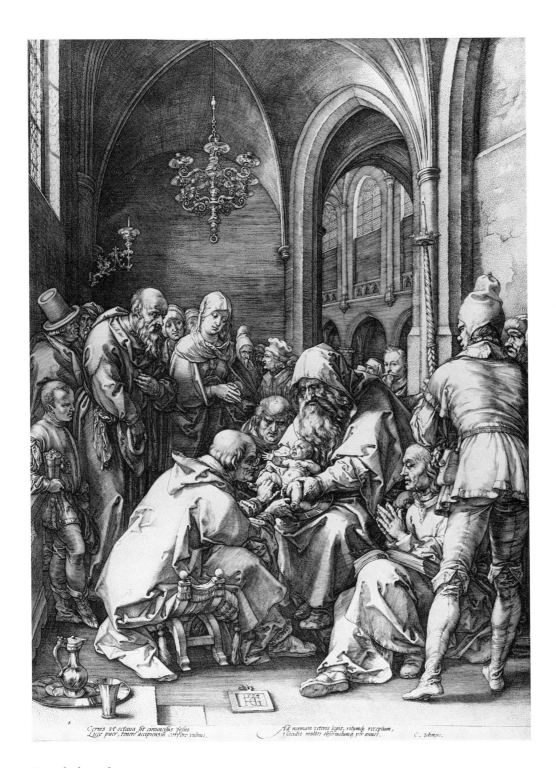

Cernis vt octaua sit circuncisus Iesus
Luce puer, tenero accipiensin corpore vulnus.

Ad normam veteris legis, ritumq receptum,
Iisidis multis observatumq per annos.

C. Schonæus.

Hendrik Goltzius, 1558–1617

Engraver. Born at Mühlbracht, near Venlo, and settled in Haarlem,
1576–77. In Italy 1590–91. He turned to painting after 1600.

[3] THE CIRCUMCISION (1594)

Engraving

The setting is the Brewer's Chapel in St Bavo's, Haarlem, which is
treated here as a suitable background to the religious scene which
dominates the composition, and to which the architecture is sub-
ordinate. Goltzius was one of the most brilliant engravers of his
time, and it is in the graphic tradition to which he belonged that the
art of Pieter Saenredam (whose father Jan Saenredam, the en-
graver, was a Goltzius pupil) has its origins.

The National Galleries of Scotland

12

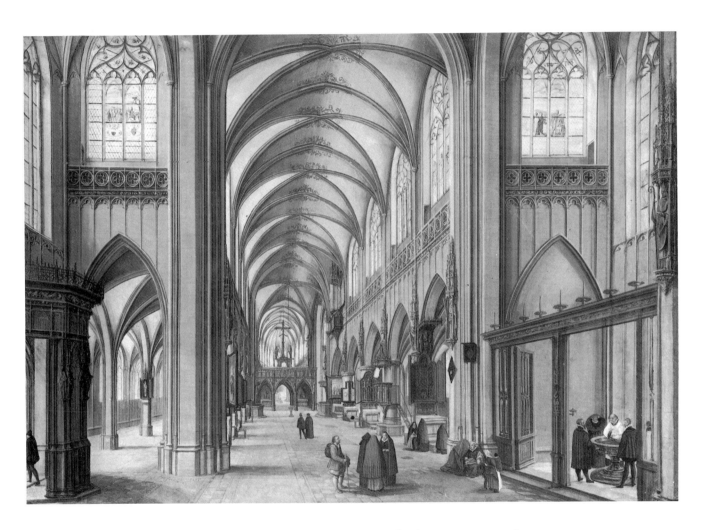

Hendrick van Steenwyck I, 1550–1603

Born Steenwyck (Overyssel). Enrolled in St Luke's Guild, Antwerp, in 1577. In 1588 he fled to Frankfurt for religious reasons, and later died there.

[4] INTERIOR OF A GOTHIC CHURCH

Gouache on vellum; 32 × 47cm
Inscribed and dated, lower left: DEESE STEEN/HEFT BEELT/ HENDRICK VAN STEENWYCK/1575

The Trafalgar Galleries, London

[5]

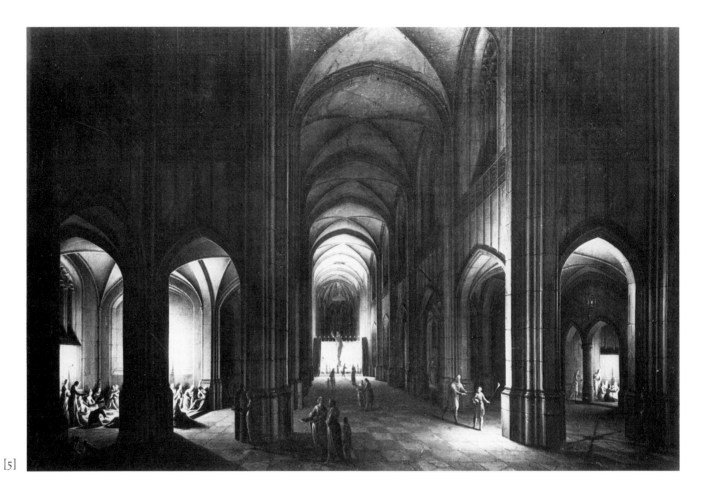

[6]

Hendrick van Steenwyck II, c. 1580–1649

Probably born in Antwerp and a pupil of his father, Hendrick the Elder. Hendrick the Younger was in London by 1617, and patronised by Charles I. His portrait by Mytens (1627), now at Turin, contains an architectural fantasy by Steenwyck. Settled in Holland about 1645 and died there.

[5] INTERIOR OF A CATHEDRAL, WITH A SCENE OF PAGAN WORSHIP AND FEASTING

Oil on panel; 63.5 × 92.5cm
Inscribed, on right: HENRI VAN/STEINWICK/INVENTOR/1591/ HENRI VAN/STEINWICK/FECIT/1624

The hands of Steenwyck father and son are often difficult to distinguish, but the claim of dual authorship recorded on this picture (ascribing the idea and design to the father, and execution to the son) is unique. A night scene within a vaulted interior was a favourite theme with the younger Steenwyck, although the subject of this picture has not been explained satisfactorily. The giant figure in the distance has been described as a figure of Baal, while a variant of this composition (sold at Christie's, 18th July 1980, lot 179, repr.) has been described, for no apparent reason, as 'The priests of Bel feasting in a church'.

Exh: London, Royal Academy, *Primitives to Picasso*, 1962, no. 83.
Ref: S. Legouix, *Maidstone Museum and Art Gallery. Foreign Paintings Catalogue*, 1976, p. 43, repr.

Maidstone Museum (George Amatt Bentlif Collection)

[6] ST JEROME IN HIS STUDY

Oil on copper; 24.5 × 34.6cm
Signed lower left: HENRI/STEINWICK/162(4 or 6)

The composition is derived from Dürer's engraving of 1514 [fig. 1]. It is one of at least seven versions of this subject that are known today. The one at Siena is dated 1602 (P. Torriti, *La Pinacoteca Nazionale di Siena*, 1978, p. 288, repr. in colour); while that in the Duke of Portland's collection is dated 1624 (catalogue by R. W. Goulding and C. K. Adams, 1936, p. 63, no. 159). Steenwyck's graphic approach to painting may be seen in the way he strengthens the outlines of the composition, particularly the tiles of the floor, to give emphasis to the perspective scheme.

Exh: Edinburgh, *Works of Old Masters & Scottish National Portraits*, 1883, no. 121.

The Marquis of Lothian

[7] ST JEROME IN HIS STUDY (colour plate)

Oil on panel; 40 × 56.2cm
Signed and dated: HENRI V STEINWICK 1630

This version of the subject was in the Spencer collection (K. J. Garlick, *Catalogue of Pictures at Althorp*, The Walpole Society, XLV, 1976, p. 80, no. 620). The sunlight streaming through the window on the left is most sensitively realised in both versions.

Ref: *Artemis 81/82*, p. 14, no. 4, repr. in colour.

Joseph R. Ritman Collection

[7]

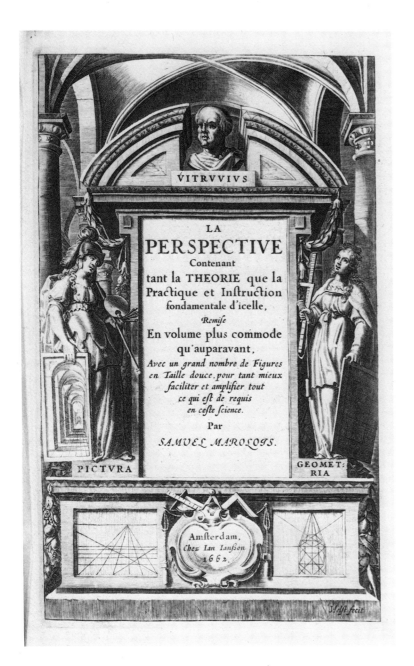

Samuel Marolois, *c.* 1572–*c.* 1627

A mathematician who lived and worked in The Hague.

[8] TITLE-PAGE TO 'LA PERSPECTIVE ...'
(AMSTERDAM, 1662).

Engraving

Marolois' treatise was first published in 1614 with three others
under the title: *Opera Mathematica ou Oeuvres Mathematiques
traictons de Geometrie, Perspective, Architecture, et Fortification
*... It was frequently republished, which is proof of its popularity.
The present design incorporates an open-topped pediment with the
bust of Vitruvius, a Roman architect and theorist whose treatise on
architecture (the only one to have survived from Antiquity), was to
have a profound influence on Renaissance architects. The title-page
also includes allegories of Painting, left, and Geometry, right. The
panels below contain two standard perspective constructions – for a
tiled floor (left), and the foreshortening of a pentagon (right).

Ref: A. K. Wheelock, *Perspective, Optics and Delft Artists around
1650*, 1977, pp. 10–12.

The British Library

[9]

Pieter Neeffs, 1578–c. 1659
(and Frans Francken III, 1607–67)

Painter of church interiors, and listed as a member of the Antwerp
Guild of St Luke by 1609. His pictures, of which the earliest
recorded is dated 1605, are difficult to distinguish from those of his
son, Pieter II (1620–75).

[9] INTERIOR OF ANTWERP CATHEDRAL

Oil on panel; 49.8 × 65.8cm

Signed, upper right: PEETER/NEEffs; and below on right: D j
ffranck. f.

This is one of many versions of the subject which survive today,
with the figures, in most cases painted by Francken, differently
grouped in each. The version at Indianapolis is dated 1651 (C.
Lawrence in *Perceptions. An Annual Publication of the Indiana-
polis Museum of Art*, II, 1982, pp. 17–21). These pictures are
interesting because they record (with little degree of accuracy, it
must be admitted) the appearance of the Cathedral after the new
altarpieces and monuments had been installed in the early seven-
teenth century, to replace those destroyed by the iconoclast riots

and to repair the damage done to the Cathedral by both Spanish and
Dutch troops. Of particular interest are the sculptures of the Virgin
and the Apostles, which were placed as commemorative figures
(about 1610/57) against the columns of the nave. These were
destroyed at the end of the eighteenth century.

Ref: C. M. Lawrence, *Flemish Baroque Commemorative Monu-
ments, 1566–1725*, 1981, chapter III.

Private Collection

Follower of Pieter Neeffs

[10] INTERIOR OF A GOTHIC CHURCH

Oil on panel; 42 × 52cm

The present attribution, in substitution for an earlier one to the
younger Steenwyck, is the suggestion of T. T. Blade. It is a good
example of studio production, in this case by a good hand. The
composition is imaginary, but based on a view of Antwerp Cathe-
dral, with the famous rood screen at the east end replaced by an
altarpiece.

Private Collection

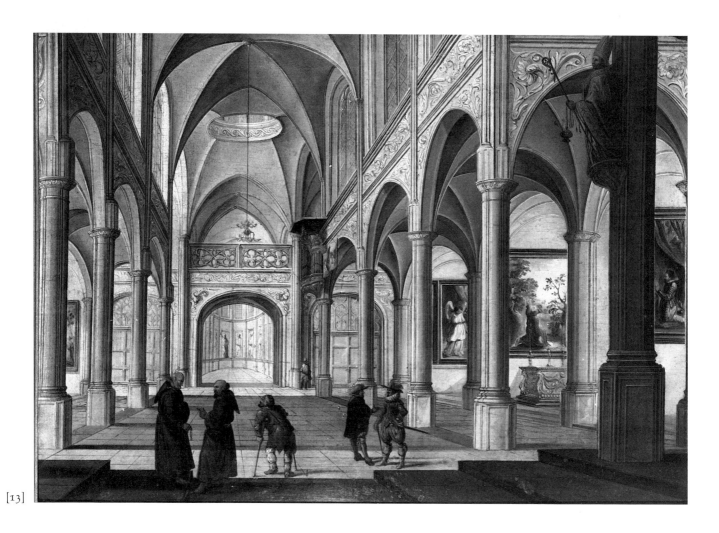

[13]

Dirck van Delen, 1604/05–71

By 1626 he had settled at Arnemuiden, near Middelburg, where he is recorded a member of the painters' guild, 1639–65.

[11] CONVERSATION IN A PALACE COURTYARD

Oil on panel; 54 × 47cm

Signed and dated, lower centre: D V (in monogram) DELEN. F. 1644

A characteristic example of Delen's palace views. In certain cases, they may have been of the villas which at one time existed along the Vecht and the Amstel (now destroyed), or more likely, of fantasy buildings which in inspiration owe much to De Vries's prints [2]. The Venus and Cupid in the niche is after a print by Marcantonio Raimondi. Of the various specialists with whom Delen collaborated it has been suggested that David Teniers, the Younger, painted the figures in this picture.

Ref: T. T. Blade, *The Paintings of Dirck van Delen*, 1976, p. 238, no. 70.

The National Galleries of Scotland

[12] GOTHIC CHURCH INTERIOR WITH CHRIST AND THE WOMAN TAKEN IN ADULTERY

Oil on panel; 40.9 × 61cm
Signed and dated: *DVDele / fecit. 1627*

Ref: *University of Glasgow. The Smillie Collection* (Catalogue by H. Miles), 1963, no. 6, pl. 7.

Hunterian Art Gallery, University of Glasgow (Smillie Collection)

[13] INTERIOR OF A CHURCH

Oil on panel; 35.9 × 52.3cm
Signed and dated, bottom right: DI. K. VAN . . . E. 1638

Ref: S. Legouix, *Maidstone Museum and Art Gallery. Foreign Paintings Catalogue*, 1976, p. 14.

Maidstone Museum (Thomas Charles Collection)

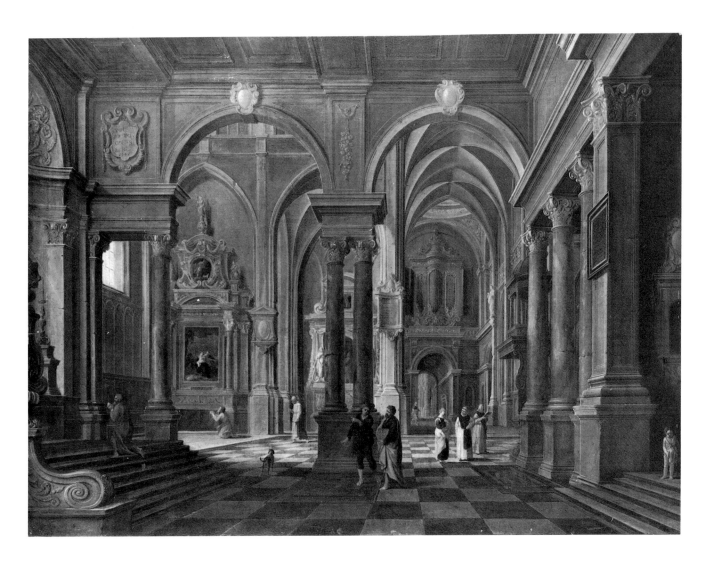

Bartholomeus van Bassen, c. 1590–1652

A member of the Guild of St Luke, Delft, in 1613. By 1622 he had settled in The Hague, where he became town architect.

[14] IMAGINARY CHURCH INTERIOR

Oil on canvas; 100.3 × 135.8cm
Inscribed, signed and dated: OMNIA NO.POSSIMVS OMNES B V BASSEN 1645

Like Delen, Van Bassen is a transitional figure in the development of Dutch architectural painting. This painting is a fine example of the fanciful tradition which originated in Antwerp. The choice of colour, predominantly brown on the left and grey on the right, is characteristic of Van Bassen. He collaborated with figure painters (e.g. Frans Francken II of Antwerp) and it has been suggested that the figures in this picture are by Poelenburg.

Exh: Utrecht, *Nederlandse Architectuurschilders 1600–1900*, 1953, no. 7, pl. 18; Utrecht, *Saenredam*, 1961, no. 239, pl. 230.
Ref: Dutch and Flemish, *Netherlandish and German Paintings in the Glasgow Art Gallery* (Catalogue by H. Miles), p. 21, no. 2, repr. p. 34.

Glasgow Art Gallery and Museum

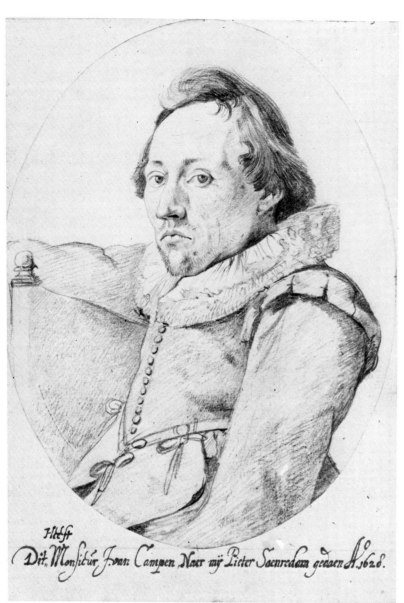

[15]

Jacob van Campen, 1595–1657

The architect of the Town Hall, Amsterdam, and the greatest exponent in the Netherlands of the Classical style. Born at Haarlem and (like Inigo Jones) trained as a painter. In Italy *c.* 1615–21, and returned a dedicated Palladian. He designed the Mauritshuis in The Hague (1633–5); and the New Church, Haarlem (1646–9).

[15] PORTRAIT OF PIETER SAENREDAM

Black chalk on paper; 23.5 × 18cm (oval)
Inscribed in ink on mounting paper, below, in the sitter's hand: *Dit heeft Monsieur J. van Campen Naer mij Pieter Saenredam gedaen A° 1628* (Mr J. van Campen has made this of me, Pieter Saenredam, A° 1628).

Saenredam was a hunchback and is revealed in this wonderful portrait as an ascetic and melancholy looking man. It is remarkable that it is one of only two portraits that have survived by his friend, Van Campen, who was a fellow pupil in the studio of Frans Pieter de Grebber.

Ref: A. M. Hind, *Catalogue of Drawings by Dutch and Flemish Artists. . . in the British Museum*, 1926, III, p. 65: Utrecht, 1961, no. 246, repr. as frontispiece.

The British Museum

Jan van de Velde II, after Pieter Saenredam

[16] INTERIOR OF ST BAVO'S CHURCH,
CALLED THE 'GROTE KERK', AT HAARLEM

Engraving and etching

This is one of the plates which Saenredam designed for the third edition of Samuel Ampzing's *Beschryvinge ende Lof der Stad Haerlem in Holland*, 1628 (Description and praise of the town of Haarlem in Holland). The author was a preacher and historian, and his book is one of several illustrated descriptions of Dutch towns which were published in the seventeenth century, e.g. Orler's description of Leyden (1614); Balen's of Dordrecht (1677); and Van Bleyswijck's of Delft (1667). Saenredam's preliminary drawing (1627), his earliest recorded church interior, is preserved today in the Municipal Archives, Haarlem (Utrecht 1961, no. 30, pl. 31). The view, looking east down the nave with the vanishing point in the centre, is the conventional one which Saenredam was soon to abandon.

Ref: Utrecht, 1961, no. 31, pl. 32; C. S. Ackley, *Printmaking in the Age of Rembrandt*, 1981, p. 104, no. 62, repr.

The British Library

Pieter Jansz. Saenredam, 1597–1665

Born Assendelft, the son of the engraver Jan Saenredam. His widowed mother moved to Haarlem in 1609. Between 1612 and 1623 the young artist was in the studio of Frans Pieter de Grebber. His earliest dated painting (of St Bavo's) is of 1628. Recorded sketching tours in the Netherlands include visits to: 's Hertogenbosch (1632); Assendelft (1633); Utrecht (1636); Amsterdam (1641); and Rhenen (1644). He played an active role in the painters' guild of Haarlem. He is buried in St Bavo's.

[17] INTERIOR OF ST BAVO'S CHURCH, CALLED THE 'GROTE KERK', AT HAARLEM (colour plate)

Oil on oak, consisting of six vertical panels each 24cm wide, except that on the extreme right, which is 23.5cm; 174.8 × 143.6cm
Condition: Very good. There is a fairly widespread scatter of small paint losses due to flaking. The areas worst affected are around the repaired join and in the top left quarter of the panel. The varnish is discoloured.
Signed, dated and inscribed, bottom left corner: *Dit is de Cathedrale grote kerck / van haerlem, in hollandt. / Pieter Saenredam, dese met schilderen / voleijnt, den 27 februarij. 1648* (This is the Cathedral Great Church of Haarlem in Holland. Pieter Saenredam, finished painting this, the 27 February 1648)
The significance of the graffiti below the inscription and accompanying word SIC, is discussed by S. Alpers in *Art & Antiques*, April 1984.

Provenance: It has been suggested that it is the picture to which Saenredam refers in a letter (the only one of his to have survived) to Constantijn Huygens, of 21 May 1648, as being on offer to the Stadholder Prince William II. Altogether more certain is the identification, now generally accepted, with the picture described in an inventory drawn up *c.* 1666–7 of Charles II's collection ('Peter Sauredam. Harlaem Church. A prospective Dutch p^{r}sent'). Although neither subject nor artist are mentioned in the documents relating to the so-called 'Dutch Gift' it is probably the painting purchased from the Burgomaster of Amsterdam, Andries de Graeff, by the States of Holland and West Friesland and presented with other pictures and sculptures to the King in 1660. It is last recorded in the Royal Collection in an inventory of 28 October 1714. In the collection of Major Sir Thomas Neave, 5th Baronet (1874–1940); and in 1934 with the dealers Asscher and Welker, London, from whom it was purchased by the 4th Marquis of Bute. By descent to the 6th Marquis of Bute, Mount Stuart, Rothesay. The picture was purchased by the National Gallery of Scotland, by private treaty, from Messrs Agnew in 1982, with the aid of grants from the National Heritage Memorial Fund, the National Art-Collections Fund (William Leng Bequest), and the Pilgrim Trust.

The Subject: St Bavo's, or the Great Church, is one of the finest Gothic buildings in the Netherlands. It was rebuilt after the fire which swept Haarlem in 1328, although its reconstruction extended over a century (choir and ambulatory, 1397–1400; transept, 1445–56; nave and aisles, 1472–81; the wooden vault in the choir constructed 1529–31, and that in the nave 1535–8). The organ inscribed ' . . . ZANGEN EN GEESTLYCKE LIEDEKENS' (hymns and spiritual songs). This is a quotation from Colossians ch. 3, v. 16, which in full reads: 'teach and admonish one another in psalms and hymns and spiritual songs' (see Schwartz, *Simiolus*, 1, 1966–67, p. 89, note 36).

The view of the church in Saenredam's painting is from the north side of the choir, looking west down the nave, with part of the south transept visible on the left. It remains much the same today, except that the great organ was replaced by an instrument erected at the west end in the 1730s [fig. 17], thus obliterating the window. There is a more detailed view of this in the painting by Berckheyde [29].

The painting visible in the south aisle [fig. 16], still survives (at present in the Frans Halsmuseum). It represents an exterior view of the church from the north side, painted in the early sixteenth century and is attributed to Pieter Gerritsz. (exh: Amsterdam Rijksmuseum, *Middeleeuwse Kunst der Noordelijke Nederlanden*, 1958, no. 94). The wall painting on the south aisle has not survived. The woman on the left of the group wears a skull cap to keep her mantle in position.

Exh: London, Victoria and Albert Museum, *The Orange and the Rose*, 1964, no. 65, pl. VII.
Ref: Utrecht, 1961, no. 58, pl. 60; J. G. van Gelder, *Burlington Magazine*, CV 1963, p. 541, note 1; D. Mahon, *Burlington Magazine*, XCI, 1949, p. 350; and XCII, 1950, p. 238; A.-M. Logan, *The 'Cabinet' of the Brothers Gerard and Jan Reynst*, 1979, pp. 75–81, the Saenredam repr. fig. 25.

The National Galleries of Scotland

[18] INTERIOR OF ST BAVO'S: VIEW OF THE NAVE AND THE WEST END

Pen and black chalk, heightened with white and yellow, on blue paper; 54.1 × 38.8cm
Signed and dated, upper right: *Den 25 augustij / anno 1635 / Pieter Saenredam*
Inscribed at the top edge in a later hand: *De Cathedrale, En Parochiale, Grootte-kerck, Binnen Haerlem, oock geheeten / Sinte-Bauo* (The Cathedral, and Parochial Great Church in Haarlem, also called St Bavo's)

The free-hand drawing on which the Edinburgh painting is based. The 'eye-point', which remained the same both in the construction drawing and painting, is indicated on the right-hand side of the first pew on the right.

Exh: Utrecht 1961, no. 59, pl. 61.

Gemeentearchief, Haarlem

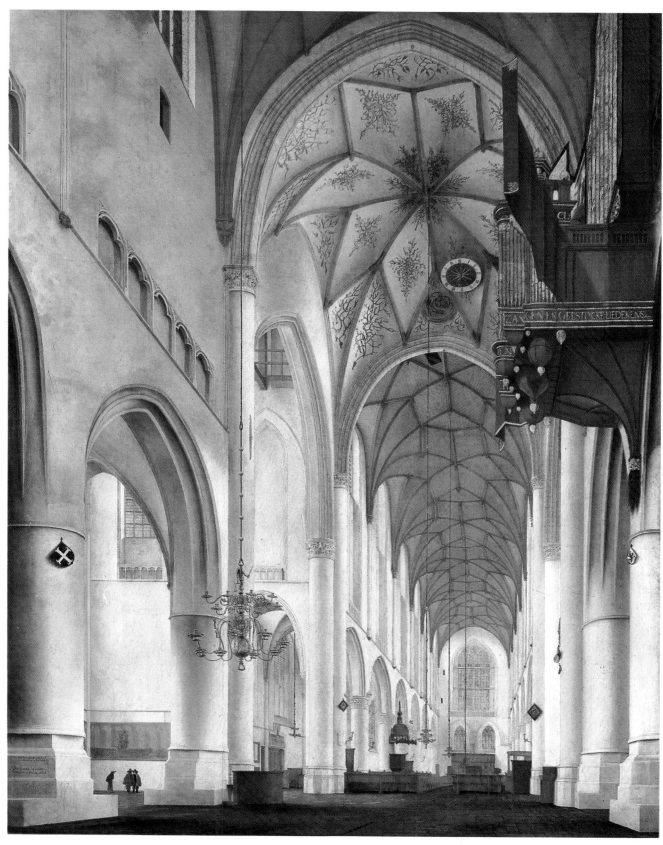

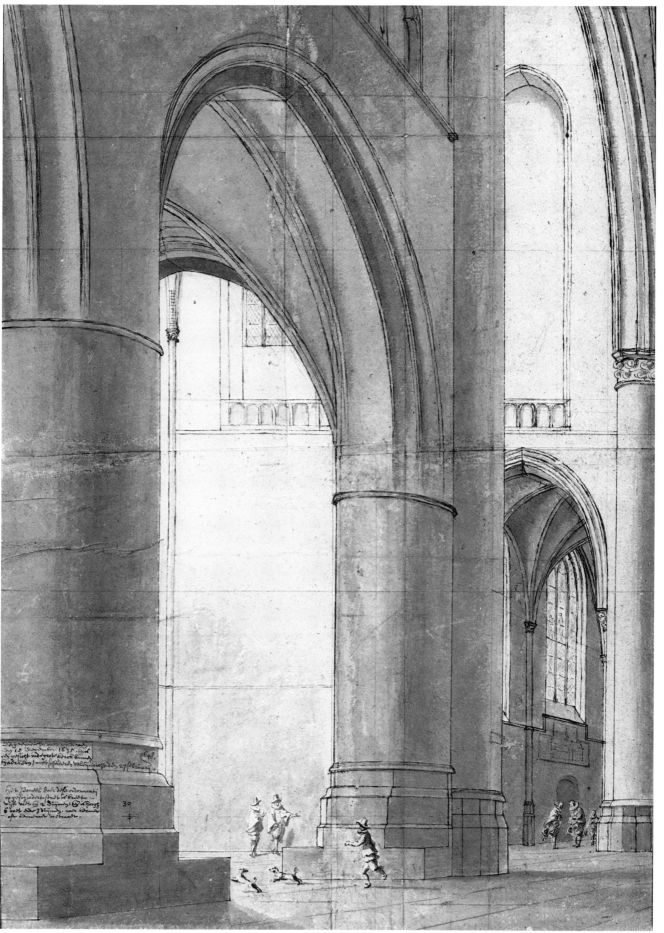

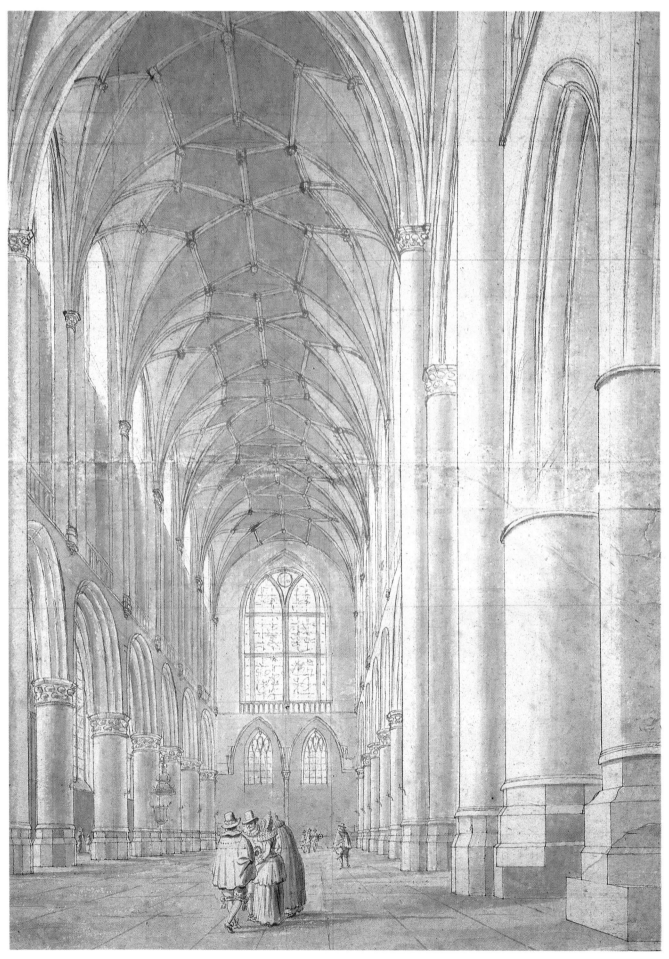

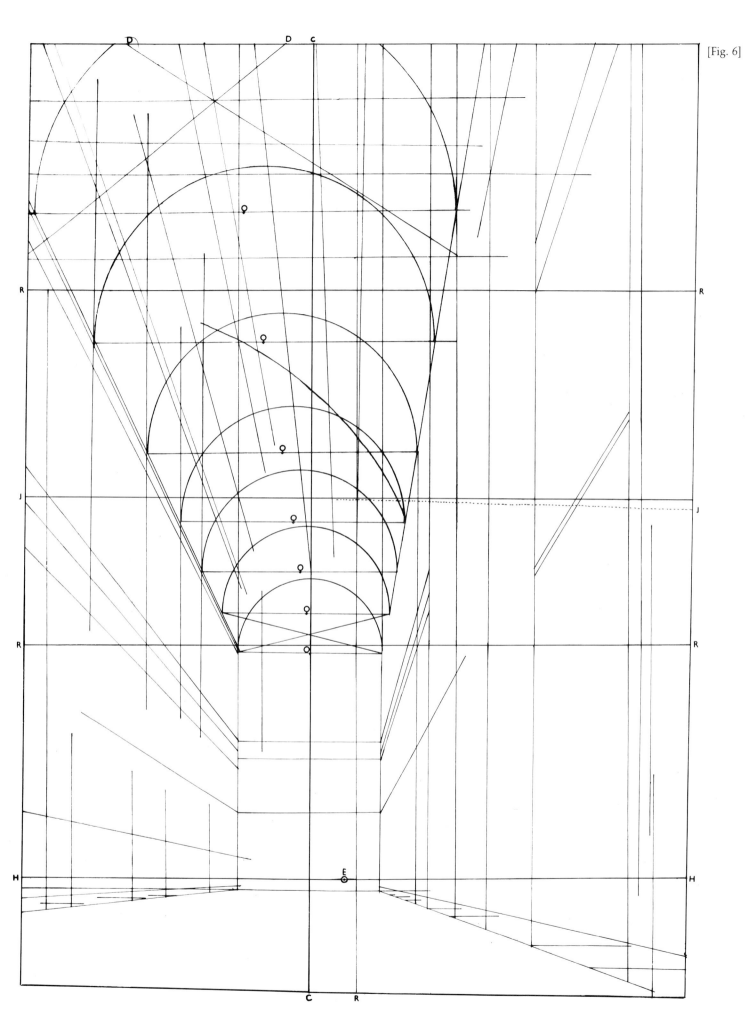

[Fig. 6]

Construction and Cunning: The Perspective of the Edinburgh Saenredam

Martin Kemp

An intricate and detailed perspective painting of a complex building cannot be achieved without a great deal of careful planning. The early seventeenth-century artists and theorists had developed a wide range of elaborate geometrical techniques for depicting real and imaginary space. Which of the many possible approaches did Saenredam use?

Two main types of evidence help us answer this question. One concerns any knowledge we may possess of the artist's intellectual life – his studies, his theories and his contacts. The other concerns detailed inspection of the actual painting, using modern techniques of scientific examination, and analysis of any preparatory drawings which may have survived. This essay is chiefly concerned with the second body of evidence, but we do have some revealing information relating to his intellectual environment.

Saenredam experienced first-hand contacts with advanced architectural and scientific practitioners. He was closely associated with Jacob van Campen, the pioneer of the geometrical style of classical architecture in Holland. At the time of Ampzing's *Beschryvinge . . . in 1628* [16], he came into contact with Pieter Wils, a mathematician, astronomer, surveyor and authority on fortifications. And one of his patrons was Constantijn Huygens, the major Dutch scientist.

By a stroke of good fortune, we have recently learnt of some books from Saenredam's library.* He owned treatises by Vitruvius, Serlio, Dürer and Scamozzi, all of which were concerned to a greater or lesser degree with the relationship between visual beauty and geometry. He possessed seven books on mathematics, including three Euclids. Three treatises by Simon Stevin were in his collection, one of which was annotated by Pieter Wils. Stevin, a mathematician and expert on military science, was an authority on perspective. Although his advanced book on geometrical perspective, *De Sciagraphia* (1605), is not on the surviving list, the mathematical tenor of Saenredam's interests is clear. How are these interests reflected in the painting and related preparatory drawings?

Saenredam began with a detailed, free-hand drawing [18], made on the spot on 25 August 1635. At this stage he was largely unconcerned with geometrically accurate perspective, rather wishing to record the salient features of the architecture and to capture its subjective 'feel'. Even so, he has laid down an optically precise marker for later reference. A dot circumscribed by a circle below the right window denotes his 'eye-point'; that is to say the main axis of his view – his line of sight – parallel to the arcades and perpendicular to the end wall (line V on fig. 11). In one respect his first drawing has gone seriously out of step. The arcade to the right (north) has been drawn much lower than that on the left (south). The two windows in the end wall are at the appropriate level in relation to the arches on the north, but badly out of alignment with those on the south. He has realised this error, indicating the top of the left window at its proper position, and marking the two top points with 'X's to remind himself to make the correction.

The next stage, which involved the introduction of a geometrical armature for the perspective, is represented by the two surviving portions of an elaborate construction drawing [19 and 20], which together comprise just over half of the total composition [fig. 7]. It has proved possible, on the basis of a fine colour facsimile, to trace a reasonable percentage of the graphite lines which underly the pen and wash detail of the right portion [fig. 6]. These represent the

geometrical framework of precise perspective onto which the architectural features were to be drawn. The armature resembles that in one of Vredeman de Vries's instructional engravings [fig. 12]. There are a number of common features: the semicircular arcs from which the vaults are constructed; the orthogonal lines converging on the vanishing (or 'eye') points (E in figs.), which serve to organise the perspective location of key points in the vaulting pattern and arcades; the clearly-defined horizon lines (H); and the diagonals (D) across the first bay and main crossing in Saenredam's construction and across the single bay of De Vries's vault. Saenredam has, however, departed radically from the engraver's conventionally centralised arrangement, moving his eye-point to the right and lowering it. This gives a new variety to the spatial patterns and effectively emphasises the awesome sense of height. To accomplish this adjustment he required a greater technical understanding of the concept of viewpoint than De Vries exhibited in his book [1].

In establishing the architectural structure of the construction drawing, he has stripped the church of most of its furnishings. Only the pulpit is lightly indicated – and on the wrong pier! Infra-red reflectography, which has revealed Saenredam's underdrawing on the panel [figs. 9 and 10], indicates that the missing elements – pews, pulpit, candelabra, armorial shields etc. – were added in detail only at this later stage. The organ was the subject of a separate study [21] and perhaps also of a full-scale construction drawing, since the reflectograms have revealed no special constructional work in this area of the panel.

Saenredam normally accomplished the transcription of the perspectival study on to the primed panel by blacking the back of a full-scale construction drawing and transferring the outlines by pressing with a sharpish instrument. In this instance, however, the dimensions of the final painting are twice those of the drawing. Do we have to assume that there was originally a full-scale drawing, which has been lost? The evidence suggests not. Infra-red reflectography has revealed construction lines in areas such as the arcading and vaults [figs. 9 and 10]. These lines would not have been necessary if a mechanical transfer had been made from a full-scale drawing. This suggests that at some point between the finishing of the construction drawing on 15 December 1635 and the completion of the painting on 27 February 1648, the artist remarkably decided to quadruple the area of his actual painting. The squares outlined in red chalk on the construction drawing [fig. 8] provided points of reference for the proportional enlargement. Lines corresponding to these squares can be seen on the surface of the panel with infra-red light [fig. 9]. The relatively large size of the squares would, however, have left a good deal of constructional work to be repeated on the panel, as the reflectograms confirm.

To what end was all this effort of geometrical construction devoted? Was it to make a perfect geometrical projection of the actual building onto the flat surface of the picture? Or was the geometrical armature designed more freely in relation to the actual dimensions of the building?

Investigations undertaken by Mahdad Saniee have revealed an intricately controlled compound of precise reference to the actual building and cunning contrivance for the sake of artistic effect. A precise perspective projection [fig. 4], using accurate plans and elevations of the church, has been produced for comparison with Saenredam's perspective in the construction drawing and painting. A detailed report on this comparison is provided by the diagrams [figs. 5 and 13] and the notes which follow this essay. These enable some general conclusions to be drawn.

* R. Ruurs, 'Pieter Saenredam: zijn boekenbezit en zijn relatie met de landmeter Pieter Wils', *Oud Holland*, XCVII, 1983, pp. 59–68.

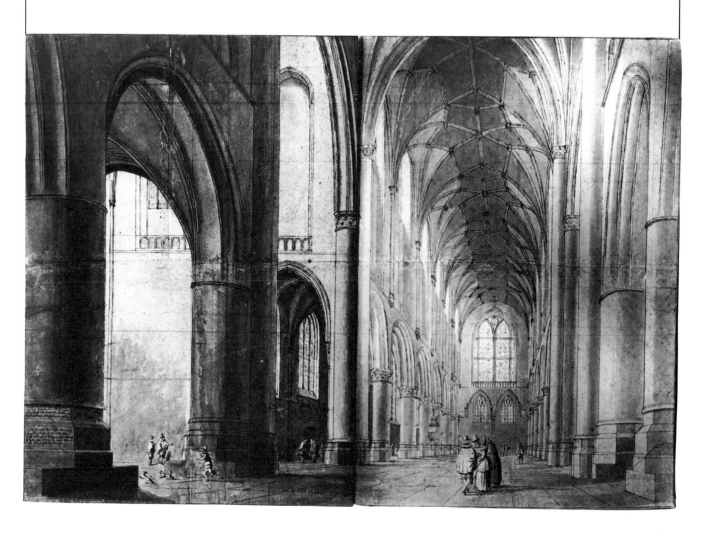

[Fig. 7] The two parts [19 and 20] of the construction drawing joined with the format of the original sheet (87.4 × 71.2 cm) indicated. Photograph by James Scott.

The comparison reveals sufficiently close correspondences in the perspective of many forms at ground level to suggest that Saenredam had recourse to precise measurements. Surviving drawings show that such measurements had been taken, probably by Pieter Wils in connection with Ampzing's book [16]. The plan [fig. 11] confirms that Saenredam has recorded with considerable precision

31

specific features visible from his viewpoint, for instance the shafts on the side wall seen through the narrow slivers of space between the nave arches. The ratio of height to width in Saenredam's end wall is also so close to reality as to suggest dependence upon accurate surveying. However, if we take the width of the crossing as a matching dimension in our comparison, the end wall is relatively smaller in Saenredam's projection, effectively deepening the tunnel of space. The relative proportions of the arcade and windows have also been significantly altered, probably in keeping with a subjective impression of the height of the arches in the actual building. The vault has been subject to similar adjustments. Many of the details of the vaulting pattern have been drawn free-hand in the constructional drawing, so that they 'look right' – which they do not necessarily in geometrical projection. More radically, the whole vaulting pattern has been stretched vertically in response to the considerably elevated profile of the crossing arches. The relative increase in height of the apex of the crossing arches above the capitals is of the order of one half. This provides a sense of soaring verticality which is absent from both the free-hand sketch and the strict projection. This effect corresponds beautifully to the special sense of graceful ascent evoked by great Gothic interiors.

The proportional adjustments are also beautifully attuned to the surface composition; that is to say, the way in which the linear structure works both in space and as a surface harmony. None of Saenredam's contemporaries came close to achieving such an equilibrium between perspectival depth and compositional flatness. The unusually wide viewing angle, which can be calculated as 80° [fig. 11], plays an important role in this respect, since it tends to emphasise the profiles of forms which lie parallel to the picture plane (i.e. perpendicular to the axis of his vision). It is also noticeable that the vertical division at the centre of the composition – corresponding to the junction of the two portions of the construction drawing – runs precisely along the line dividing the shafts of the crossing pier. However, the harmonising of space and surface is not only a matter of linear composition. It is also dependent upon his subtle use of tone. The patterns of light and shade caress forms into three-dimensionality and enhance the crystalline space, yet at the same time their delicate reticence prevents them from working against the linear design drawn by the artist's hand on the surface.

The more fully we have analysed the mechanics of Saenredam's masterpiece, the more miraculously balanced it has seemed between reality and artifice. Sustained analysis has served to deepen our respect for its creator's magic.

Supplementary Notes
on the Construction Drawing and Painting

The combined width of the two surviving portions of the construction drawing is 71.2cm. Doubled dimensions provide a width of 142.4cm. The panel is 143.6cm. wide. The difference of 1.2cm is explained by the painted surface commencing inside the edges of the panel.

The lines in reddish chalk divide the drawing into squares equal to one quarter of the width of the composition [fig. 8].

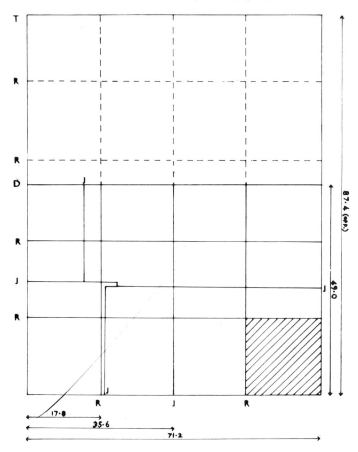

[Fig. 8] FORMAT OF THE CONSTRUCTION DRAWING

The solid lines correspond to the surviving positions and outline of the whole drawing; the dotted lines refer to the reconstruction of the squaring on lost upper portion. All measurements in cms.

T top of construction drawing as reconstructed
D top of surviving portions
J joins in the sheets of paper from which the surviving portions have been assembled
R lines in reddish chalk sectioning the composition into squares. The shaded section on the lower right denotes one of the squares

The viewing angle is 80° [fig. 11], giving a viewing distance of 78cm. for the panel, which is too short for practical purposes. The artist did not, therefore, expect his perspective to be viewed from a single, perfect point.

The artist's viewpoint is equivalent to that of someone sitting in an upright chair. The marking '30' on the leftmost pier of the construction drawing [19] appears to correspond to 3.0 Dutch 'voet'.

The crossed circle on the leftmost pier in the construction drawing [19] appears to be a secondary point of reference, but it

does not function as a second 'eye-point', since all the forms in the drawing and painting are perspectively foreshortened from the main 'eye-point'.

The functions of most of the graphite and ink lines in the construction drawing are clear. The arc running diagonally across the 3rd and 4th bays of the nave vault is unexplained. The cross on the convex surface of the nearer crossing pier on the left does not correspond to a visible feature, but may record the position of the vertical shaft at the junction of the aisle and transept wall behind the pier.

The piers of the nave, crossing and choir have been erected on a perspectival grid on the ground plane which determines the location of their bases.

The pavement lines and candle-holders on the piers in the drawing are added freehand and do not run consistently to the 'eye-point'.

The positions of the organ and its shutters relative to the vault patterns and crossing arches have been taken over closely from the Lugt Collection study [21].

The vaulting pattern of the crossing in the painting differs from that in the present church. Berckheyde's *Interior of St Bavo's* (1673) in the National Gallery, London, confirms that the crossing vault has later been reconstructed.

The drawing and painting show more of the ribs of the vaults behind the crossing arches than could have been visible from Saenredam's viewpoint.

The levels of the capitals from which the nave vaults spring are slightly higher on the right than the left in the construction drawing and painting.

The height of the capitals at the top of the tall shafts of the crossing in relation to the width of the crossing is close to that in the church, but the relative height of the apex of the crossing arches above the level of the capitals is 54% greater in the painting.

The end wall is proportionately smaller in Saenredam's projection, if the width of the crossing is taken as a matching dimension. Alternatively, if the end wall is taken as a matching dimension, the majority of the perspectival projections at ground level are thrown out of correspondence, which is a less satisfactory solution.

The ratio of the height of the round shafts of the nave piers to the height of the horizontal moulding above the arcade is 1:2.95 in the church, whereas in Saenredam's construction it is 1:2.62.

The construction drawing accurately reveals details of the architecture (e.g. an aisle window) obscured in the freehand drawing by the furnishings of the church.

The occlusion of distant forms by nearer forms from his particular viewpoint is meticulously observed for the most part. The most notable exception concerns the forms visible through and under the first arch of the choir on the left. More of the end wall of the transept should be seen (i.e. according to the line R rather than line S on fig. 11); the vertical shaft at the junction of the side and end walls of the transept is far too thin; more of the aisle vault should be visible. This area is not depicted in the freehand drawing [18], and may have been constructed from memory. Pentimenti are visible in the aisle vault of the choir in the construction drawing, indicating his difficulties in this area.

The figures in the painting are too small in proportion to the architecture, unlike those in the construction drawing which are correctly proportioned.

Notes on the Infra-red Reflectography

See figures 9 and 10 (pages 34 and 35)

Orthogonal lines in perspective provide the location of key points – the bosses of the vaults, upper capitals of the wall shafts, blank arcading below the upper windows, top of the arcade arches, capitals of the round piers, etc. – though on a simpler basis than the graphite underdrawing in the construction drawing.

Within this framework, the forms are drawn in some detail, many of them freehand. Some of the more difficult shapes, such as the pointed arches, continued to pose problems of foreshortening and were subject to further adjustments.

The furniture of the nave, the pews, pulpit, candelabra, etc., which had been excluded from the construction drawing, have been drawn with elaborate care using both freehand and ruled perspective lines.

No constructional lines are visible under the organ, which must therefore have been subject to an independent constructional process.

The horizon line (corresponding to H in fig. 6) has been clearly established on the panel.

Ruled horizontal and vertical lines correspond to the reddish ink squares in the construction drawing.

Other horizontal and vertical lines locate key elements in the architecture as in the construction drawing.

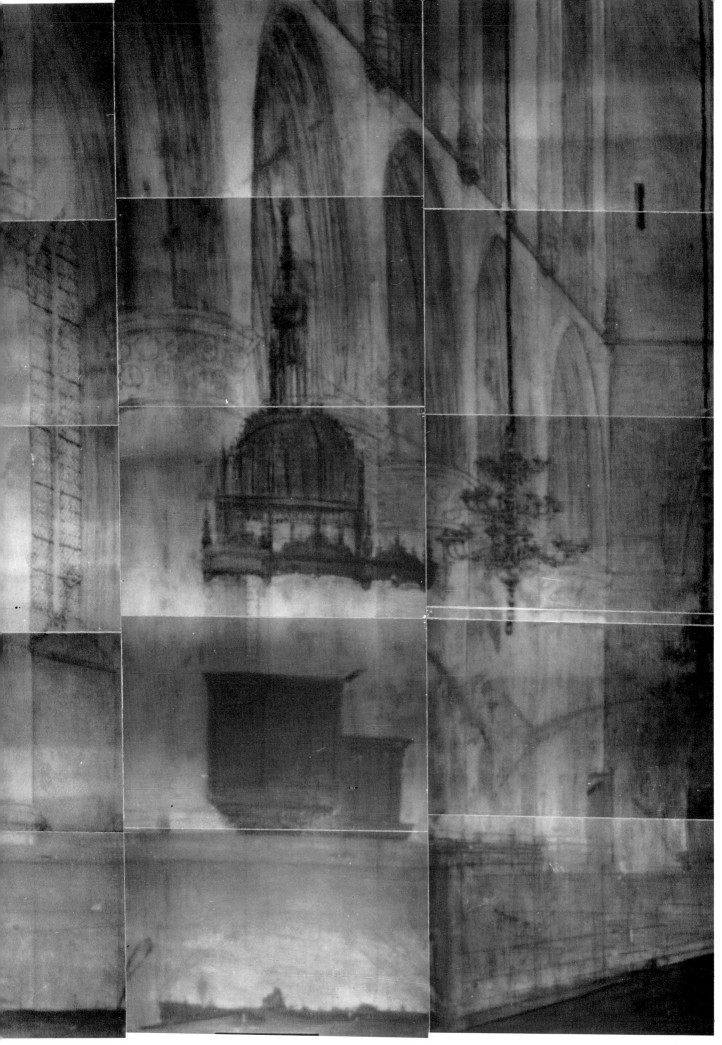

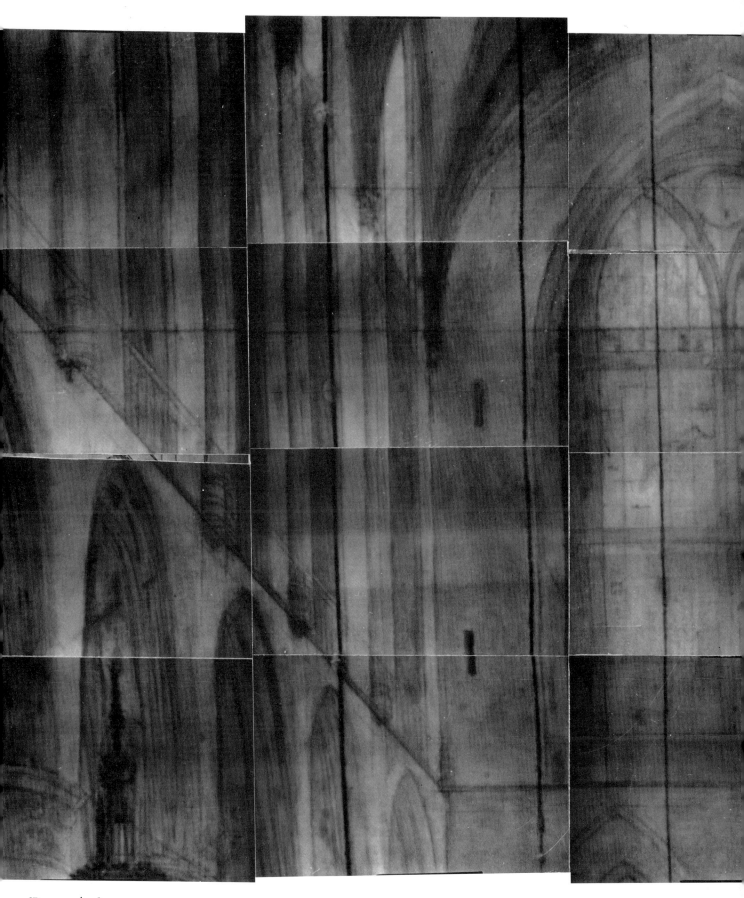

[Figs. 9 and 10] TWO DETAILS OF THE UNDER-DRAWING
OF THE EDINBURGH SAENREDAM

The process of transferring the design to the panel, which is twice the size of the construction drawing [fig. 7], was done by squaring the latter in red chalk. Having thus established certain points of reference (the line bisecting the window in fig. 10, for example, corresponds to the red line on the Woodner drawing, no. 20), the artist then re-drew the design on the panel, at certain places in great detail, as these reflectograms show. Note the perspective grid, and the method of drawing the cabbage-patterns on the capitals which is the same as on the construction drawing. The shadowed areas on the right of certain of the arches are an indication of the trouble Saenredam had in establishing their correct shape. Reflectograms by John Dick.

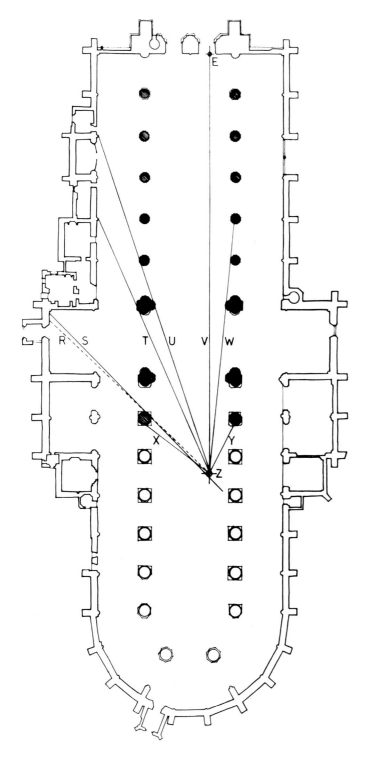

[Fig. 11] PLAN OF ST BAVO'S,
DEMONSTRATING SAENREDAM'S VIEWPOINT.

E 'eye-point' marked on end wall
R 'correct' line of vision into transept from Saenredam's
 viewpoint
S line of vision into transept as in the construction drawing
 and painting
T/U lines of vision of shafts on S. wall of nave
V axis of Saenredam's vision
W line of vision of 4th pier of nave
X/Y lines of vision delimiting the visual angle of the painting
 at 80°
Z Saenredam's viewpoint

Schematic drawing by Mahdad Saniee, based on the plan of the
church supplied by H. W. van Kempen and G. Lankhorst.

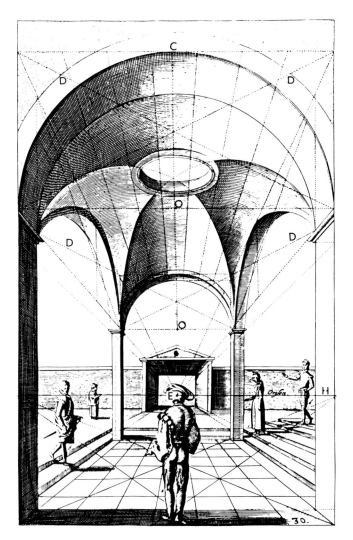

[Fig. 12] Jan Vredeman de Vries, VAULTED SPACE WITH FIVE
FIGURES. (From *Perspective*, 1604–5, Part I, pl. 30 – labelled to
correspond to fig. 6).

C vertical line, marking central axis
D/D lines running from diagonally opposite capitals of the vault
E 'eye-point'
H horizon line
O/O centres of semicircular arcs from which the vaulting arches
 are constructed

[Fig. 13] RELATIVE DIMENSIONS
OF THE WEST END WALL OF ST BAVO'S (left)
AND SAENREDAM'S CONSTRUCTION (right).

Based on measurements by Mahdad Saniee. The height of the
upper capital, marked *, is given as an average, since it is higher on
the right in Saenredam's construction than on the left.

The Organs of St Bavo's, Haarlem

Peter Williams

Today's visitors to the Bavokerk have their attention drawn to the German organ at the west end of the church, built in the 1730s to compete with those at Alkmaar and Amsterdam and becoming one of the most famous of all organs, played by Mozart and praised by Abt Vogler. But the west wall of the nave had to be bricked up to take this new organ [fig. 17] – the window and the 'island' around the pulpit far from the west end are seen in Saenredam's large painting – and for most of the previous three centuries the liturgy had centred on other parts of the church. Several side-chapels had their organs as they had their Masses, but the main musical attention was drawn to the crossing. Here, hanging on the north wall just east of the crossing (a favourite site for pre-baroque organs, as too at York, Canterbury, Durham, Old St Paul's, etc.), was a magnificent gothic creation of the late fifteenth century by Peter Gerritz (d. 1479) of Utrecht. Like many other large medieval instruments perched on their own 'swallownest' galleries, the Haarlem organ did not survive the radical eighteenth century, and only from Saenredam's paintings and drawings do we understand many details of it.

The paintings in Edinburgh [17] and the Rijksmuseum [fig. 14] show the organ from two different angles.

The Edinburgh picture [17]. The flat large organ at the back – a shallow gothic construction of 1463/6 – had in front of it space for the keyboards and organist's stool; it also had two large doors or wings (the left showing a Crucifixion scene, a detail of which is just visible) and a fretted or carved panel filling in below the outward-curving support from organ-plinth to pipechest level. The small organ in front ('back positive' or Chair Organ as it became called in England), its wing-doors, the gallery panels to the side, and most of the visible parts of the supporting structure all belonged to alterations made between the time of Gerritz and the time of Saenredam. The small organ was replaced in 1545 and much work was done on the main organ during 1630–33 by Galthus and Germer van Hagerbeer (the builders of the Alkmaar organ, 1639–45). Probably belonging to 1463–6 were the rear part of the arching support and the shaggy-bearded head from which it springs. Although there is no known reference to this head, it almost certainly moved when wind from the organ-bellows was admitted, via a stop-lever at the keyboards, to set in motion a small 'windmill' mechanism which activated it in some way. Such heads, representing Goliath, the devil or a wild man or (further east) Tartar and Turkish invaders, were quite common on those large organs of the period that had a public function. As became normal in Dutch organ-building, the large back organ was flat, the small front organ curved, cusped and planned in much greater relief. Particularly instructive is the shallowness of the large back organ. By 1536 at least, it contained two tiers of pipes within its case: the main chorus at the lower level (probably in 1463 one large Blockwerk or chorus without separate stops), and a secondary chest (with flutes, reeds, etc.) about halfway up.

The Rijksmuseum painting. The full-face view of the organ shows an astonishing detail [fig. 15]: the only clear Dutch picture of *Bourdoenen*, i.e. a set of large bass pipes, perhaps operated by keys played by the feet. This last is uncertain, however: early pedals often had nothing to do with 'bass pipes', since in 1471 (when the Haarlem pipes were added) one can hardly speak of a 'bass line' in music generally. The five pipes stand on their own little *trompe* and were indeed called 'Trompes' in contemporary contracts for organs of Normandy and the Ile de France. At Haarlem, they appear to be of 20' length (corresponding to 32' octave-pitch at bottom key of F or G). It has been assumed that there was a second such *trompe* to the left of the organ, but both the Edinburgh and Amsterdam paintings show the instrument to be between first and second bay of the choir, leaving no room for a second tower. It is uncertain, therefore, whether there were five or ten pipes, the second set positioned behind the first, perhaps, though there is no hint of this in the painting. Reference is made to either five or ten in contemporary Dutch organs (Bergen; Buurkerk, Utrecht; St John's, 's Hertogenbosch; Nijmegen etc.).

Other details are also clear from this painting. The head-and-beard is very clear, as is the fretwork carving below impost to right and left. The right wing-door of the large case contains a picture of the Resurrection,* while the wings of the small organ had no picture (the pale blue is possibly meant to represent sky, perhaps with a moon and stars, as on other organs of northern Europe). While the curved front of the small organ is emphasised by its wing-door, a much more important detail is clear from the large organ: its smaller case-pipes were not only arranged in V-patterned serried ranks (a pattern that has remained till today), but in at least five panels or 'fields' were soldered into double pipes. That is, two pipes were soldered together at their feet so that – so one may assume – their two mouths spoke together and gave an enrichment to the treble part of the overall sound-spectrum. (They could possibly have been only decorative, but some modern builders have shown how feasible such doubles are: the newly-restored organ in the Nieuwe Kerk, Amsterdam has many such ranks.)

The Rijksmuseum painting [fig. 14] also shows, hanging on the north wall of the north east aisle, a smaller organ complete with finials, wing-doors, soldered pipe-feet and swallownest gallery. Although the painting shows the room behind to be bare, it would once have served as a chantry chapel before the Reformers simplified liturgies and usages, and the organ would have been associated with – even owned by – the guild or Brotherhood or family for which the chantry chapel was furnished and endowed.† The instrument seems to have been built in the 1520s (documents speak of more than one small organ being built in the Bavokerk in and around 1523), and survived for two and half centuries; it may have been the work of the same Jan van Covelen (Johannes van Koblenz) who built the still extant and not dissimilar small aisle-organ in the Grote Kerk, Alkmaar. The lattice-work panels in its lower part (below the pipe-chest or impost level) may well have been so made in order to allow the sound of a regals stop placed there 'in the breast' to escape.

* Painted by Vrederick Hoon in 1465 – see J. Bruyn, *Bulletin van het Rijksmuseum* XI, 1963, pp. 31–8.
† St Bavo's would appear to have had three such small organs; the second is visible in the Saenredam drawing [24], and the third in the picture by Berckheyde [29].

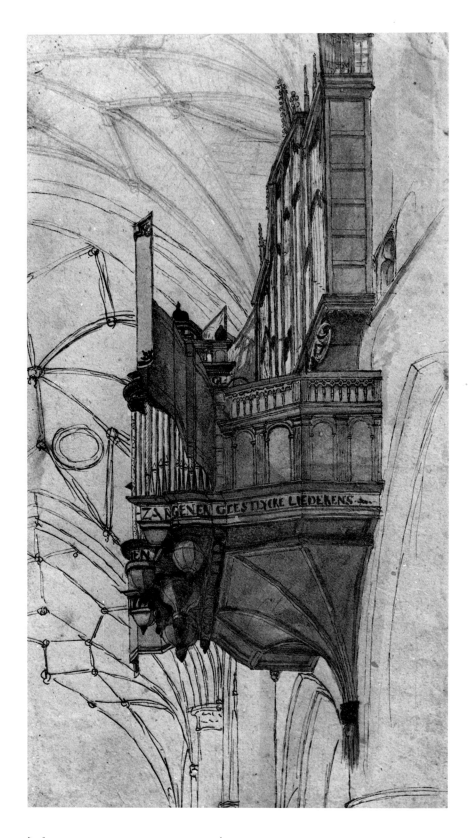

[21] THE GREAT ORGAN OF ST BAVO'S

Pen and brown ink, graphite and watercolour; 30.9 × 17.3cm
Inscribed: ZANGEN EN GEESTLYCKE LIEDEKENS.

The instrument which is the subject of this drawing is discussed by Peter Williams on page 38 of this catalogue. The drawing has been dated 1634/5. If the organ had been included on the construction drawing, as claimed in the catalogues of the exhibitions mentioned below, part of it would appear on the sheet belonging to the Woodner Collection – which it doesn't. Saenredam was obviously interested in organs and understood how they were constructed. It would be possible in many cases to reconstruct the instruments which appear in his paintings and drawings, although the evidence in the latter is sometimes sketchy and small in scale.

Exh: Utrecht 1961, no. 66, pl. 67; New York and Paris, *Rembrandt and his Century. Dutch Drawings of the Seventeenth Century from the Collection of Frits Lugt, Institut Néerlandais, Paris,* 1977/78, no. 99, pl. 42.

Fondation Custodia (coll. F. Lugt), Institut Néerlandais, Paris

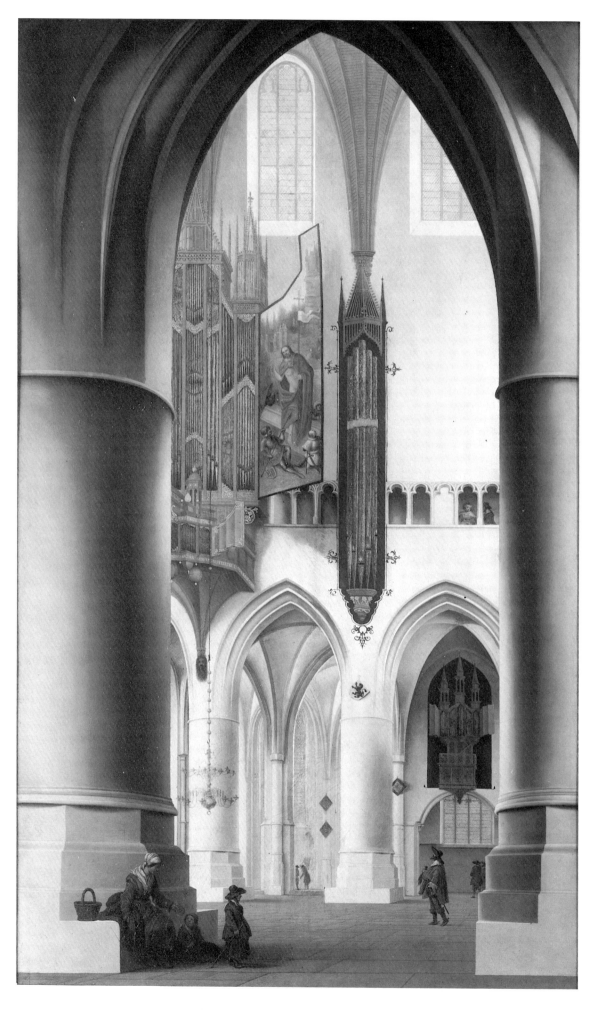

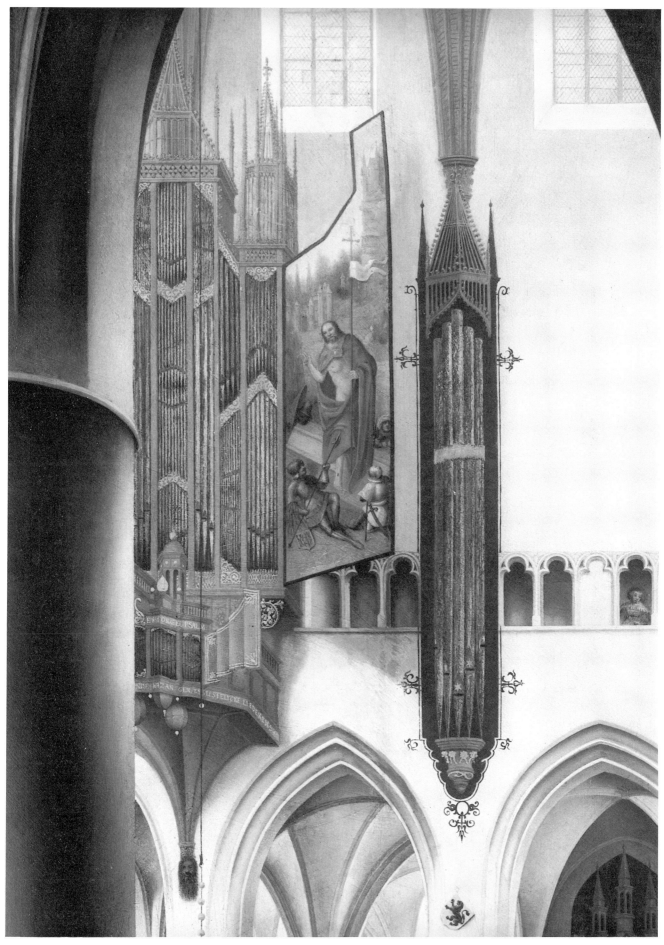

[Fig. 14] Saenredam, INTERIOR OF ST BAVO'S WITH A VIEW [Fig. 15] Detail of Fig. 14.
OF THE GREAT ORGAN. 1636. Amsterdam, Rijksmuseum

The Use of Organs in Dutch Churches

Peter Williams

The Haarlem organ, then, had a mixed heritage and represents, in Saenredam's paintings, a typical situation in the larger churches by the middle of the seventeenth century, i.e. after the town had become thoroughly Protestant and the church had been turned to reformist use, with prominent pulpit and with stalls to allow the careful attention to sermons. The organ itself, however, was not part of the ceremonies; not only was it not required to accompany the hymns in most cases, but it was so placed as to be useless had it been so required. The new protestant organs at Alkmaar and Amsterdam Westerkerk were placed at the west end, like the new Haarlem organ of the 1730s. Nor can the old Haarlem organ have been of much liturgical significance in pre-Reformation times, for most Masses and Offices were celebrated in the chapels. Apart, therefore, from a general question of precisely what were the large gothic cruciform churches of the fourteenth and fifteenth centuries built for, there is a particular question about their magnificent and expensive organs.

Although the pre-Reformation period had little in the way of congregational singing and the post-Reformation period had no hymn-accompaniment, the organs nevertheless had several functions. Firstly, the magnificence itself was a *raison d'être*. Since at least the late tenth century, major churches of western Europe had been used to housing *exempla* of the most developed technologies of their period – vaults, glass, time-clocks, astronomical or almanac-clocks, bells, moving statuary, organs. Like a clock, an organ was 'alive' and could 'perform' something particularly appropriate, in an age in which sound was conceived as a link with other worlds. Secondly, custom created rivalries, not necessarily of a petty kind associated with commercial competition, but ones which would oblige church authorities or the Town Councils that replaced them to seek, as a duty, to match establishments of the same rank. Thus at Haarlem, the organists from *c.* 1410 to *c.* 1560 are recorded as studying instruments elsewhere and, no doubt, learning whatever music was circulating. Thirdly, from at least the early sixteenth century, the Haarlem Bavokerk had a tradition for recitals, i.e. concerts of solo organ music perhaps an hour long, perhaps on many or even all days of the week (excluding Advent and Lent?), and perhaps before and/or after the main Masses. This tradition survived the Reformation and affects today's arrangements at the Bavokerk: a Sunday organist is employed by the church for services, but the Town Council (which owns the organ) also employs an organist for secular purposes.*

Quite what Saenredam might have heard played during the 1630s and 1640s at Haarlem is not known in detail, but informed guesses can be made. Some years earlier in Amsterdam, Sweelinck is thought to have regaled his daily listeners in the Oude Kerk with transcriptions of Italian and English vocal music (transcriptions have always been a major part of organ concerts until our own period), with serious fantasias ('ricercars') and with improvised variations on suitable melodies – perhaps not always psalm-tunes and hymns, but familiar songs of the day. Presumably, seasonal melodies would feature – Resurrection songs and hymns at Easter, etc. – though there is unlikely yet to have been much in the way of carols at Christmas. It is said that at Haarlem, the 12 noon music entertained the good burghers promenading in the church, doing business standing in groups around the nave (there is much space in a large gothic church, and one can not be easily overheard); and a document of 1649 refers to the burgomaster requesting that hymns be accompanied by the organ, something which, it seems, the Church Council itself did not want. What 'accompaniment' means is not clear; the organ may have introduced the hymns sung in the services, or played variations between the verses, or extemporised postludes afterwards. The Haarlem organ was rebuilt in the 1630s only because the citizens petitioned the Town Council to provide an instrument worthy of the then organist (C. J. Helmbreeker, a pupil of Sweelinck), so that they could hear it daily and be 'better initiated into the art of music and good singing of the psalms'. At least during the sixteenth century one of the smaller organs (Chapel of Our Lady) was also used for recitals, i.e. the music that served as a postlude following the evening service (Vespers?) developed into a fully-fledged musical event.

BIBLIOGRAPHY

A. ANNEGAARN, *Floris & Cornelis Schuyt* (Amsterdam, 1973).
J. DE KLERK, *Haarlems muziekleven in de loop der tijden* (Haarlem, 1965).
F. PEETERS and M. A. VENTE, *The Organ and its Music in the Netherlands 1500–1800* (Antwerp, 1971).
M. A. VENTE, *Bouwstoffen tot de Geschiedenis van het Nederlandse Orgel* (Brussels, 1942).
M. A. VENTE, *Proeve van een Repertorium van de Archivalia betrekking hebbende op het Nederlandse Orgel* (Brussels, 1956).
M. A. VENTE, 'Bijdragen tot de Geschiedenis van het vroegere grote Orgel in de St. Bavo en zijn Bespelers tot 1650', in the catalogue of an exhibition, *Nederlandse Orgelpracht* (Haarlem, 1961), pp. 1–34.
M. A. VENTE, *Die Brabanter Orgel* (Amsterdam, 1958).
M. A. VENTE, 'De boedel van Philips Jansz. van Velsen, organist en klokkenist te Haarlem (1562–1625)', *Tijdschrift van de VNM*, 19 (1962–3), pp. 200–202.
P. WILLIAMS, *The European Organ 1450–1850* (London, 1966).

* The Dutch custom of carillon playing has certain parallels to the Haarlem organ recitals: a musician employed by the Town performs on the carillon at certain times in the day, concentrating on hymns and thus contributing to daily devotions rather than secular entertainments. There is some evidence that during the eighteenth century, Edinburgh (through the Town Council and St Giles or the Tron Kirk) attempted a similar reformist idea.

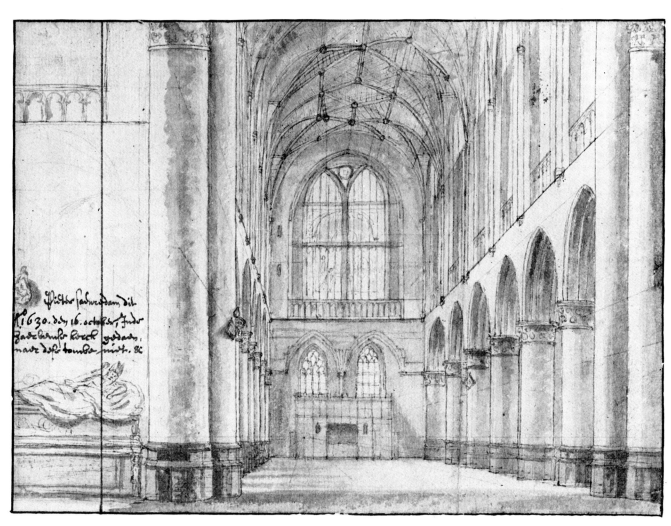

[22] INTERIOR OF ST BAVO'S:
VIEW OF THE WEST END

Pen and brown ink (the principal lines ruled) with grey wash; 12 × 16.3cm
Signed and inscribed: *Pieter Saenredam dit / A° 1630 den 16. October, inde / Haerlemse kerck gedaen, / maer diese tombe niet &.* (Pieter Saenredam: A° 1630, the 16th October, this done in the church of Haarlem, but not this tomb.)

The view is the same as in the Edinburgh painting, but taken nearer to the west end. This may be regarded as a construction drawing in miniature, with the perspective grid clearly visible below the ink lines, some of which are incised. This suggests that it was a design for an engraving. The 'eye-point' is indicated. The wall painting in the south transept, which is clearly visible in the Edinburgh picture, is here substituted for the tomb of a bishop. The accompanying inscription, which implys that it is imaginary, has been cited as an example of Saenredam's accuracy in recording what he saw – in contrast to Neeffs [9] for example, who had none of Saenredam's antiquarian approach.

Ref: A. M. Hind, *Catalogue of Drawings by Dutch and Flemish Artists . . . in the British Museum*, 1931, IV, p. 45, no. 4; Utrecht, 1961, no. 62, pl. 59.

The British Museum

[23] INTERIOR OF ST BAVO'S: VIEW OF THE SOUTH AISLE, LOOKING WEST (colour plate, page 44)

Oil on panel; 42.7 × 33.4cm
Signed and dated on the step leading to the chapel, left: *P. Saenredam. fecit Anno 1633*

A priest, left, waits for the arrival of the women on the right, one of whom is bringing a child for baptism. Figures, usually diminutive in size, always play a secondary role in pictures by Saenredam who occasionally employed specialists. The figures in the Rijksmuseum painting, to which the Edinburgh drawing relates [27], for example, are attributed to Pieter Post. The picture was cleaned in 1984; although the figures are worn and the chandelier also, it is in good condition. The construction drawing (1631) is in West Berlin (Utrecht, 1961, no. 65, pl. 66).

Exh: Utrecht, 1961, no. 63, pl. 64.
Ref: Dutch and Flemish, Netherlandish and German Paintings in Glasgow Art Gallery (Catalogue by H. Miles), 1961, p. 126, repr. p. 79.

Glasgow Art Gallery and Museum

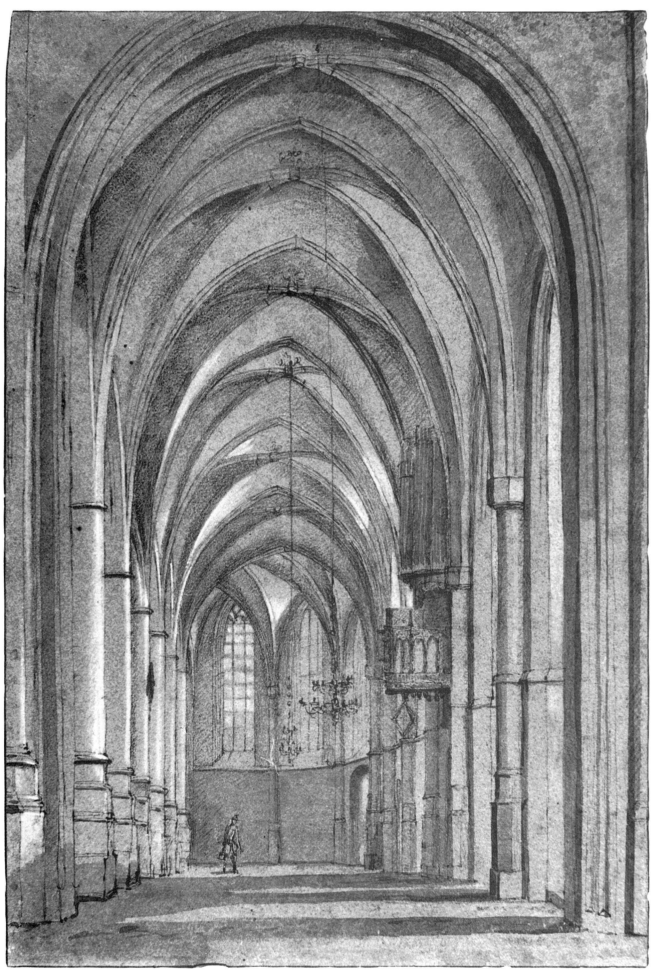

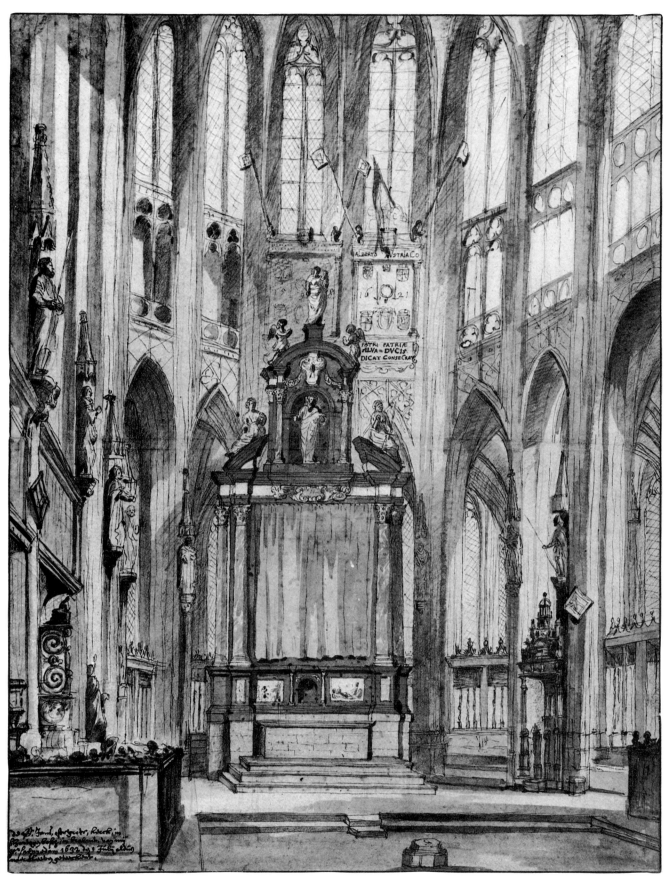

ALBERTO AVSTRIACO

16 21

PATRI PATRIÆ
SILVÆ DE DVCIS
DICAT CONSECRAT

[24] INTERIOR OF ST BAVO'S: VIEW OF THE SOUTH
AMBULATORY, LOOKING EAST (page 44)

Pen and brown ink with black chalk and grey wash, heightened with
white, on blue paper; 33.8 × 23.8cm

To be dated 1634/35. The related painting (1635) is in West Berlin,
for which the construction drawing is preserved in the Municipal
Archives, Haarlem.

The abstract patterning of the vault is typical of Saenredam,
whose handling of the light in this drawing is masterly.

Ref: Utrecht, 1961, no. 53, pl. 54.

London, Courtauld Institute Galleries (Witt Collection)

[25] INTERIOR OF ST JOHN'S CHURCH,
'S HERTOGENBOSCH (BOIS-LE-DUC): VIEW OF THE CHOIR

Pen and ink, black chalk and watercolour on paper; 40.8 × 32cm
Inscribed by the artist: *de St Jans, ofte grote, kerck, in/s' Her-
togenbosch, in brabant, van mij/Pr. Senredam 1632 den 1 Julij
aldus/naar t'leeven geteeckent.* (St John's or great church at
Bois-le-Duc in Brabant, by me Pr. Saenredam 1632 the 1st of July
drawn like this from life.)

The related painting, dated 1646, is in the National Gallery of Art,
Washington, D.C. 's Hertogenbosch was part of the Spanish
Netherlands until 1629, when it was captured by Frederick Henry
for the States General of the United Provinces. Like many other
churches the Cathedral suffered during the iconoclastic riots of
1566. The High Altar by Hans van Mildert (1616–20) seen in this
drawing, and the rood loft from the same church which is the

subject of the following drawing, are excellent examples of the
revival of Catholic patronage which flourished during the Twelve
Year Truce.

Ref: A. M. Hind, *Catalogue of Drawings by Dutch and Flemish
Artists . . . in the British Museum,* IV, 1931, p. 45, no. 1; Utrecht,
1961, no. 95, pl. 97.

The British Museum

[26] INTERIOR OF ST JOHN'S CHURCH,
'S HERTOGENBOSCH; THE ROOD LOFT

Pen and brown ink, black chalk and watercolour; 25.3 × 39.4cm
Inscribed by the artist on the base of the column, lower left: *1632
den 3 julij/Pr. Saenredam.* Along the bottom of the sheet in a later
hand: *Dit is Het kostelijcke ockzael van de St. Jans kerck in
S'hartogenbos* (This is the precious screen of St John's Church in
Bois-le-Duc).

The rood loft by Coenraed van Norenberch (1610–13) was placed at
the west end of the chancel of St John's, separating the nave and
choir. It was removed in 1866, and shortly after purchased by the
Victoria and Albert Museum. Apart from its intrinsic beauty, the
drawing is interesting because it records hands and arms of several
of the statues which have since been multilated.

Ref: A. M. Hind, *Catalogue of Drawings by Dutch and Flemish
Artists . . . in the British Museum,* IV, 1931, p. 45, no. 2; Utrecht,
1961, no. 96, pl. 99; and C. Avery, *Victoria and Albert Year Book,*
1969, pp. 110–36.

The British Museum

[26]

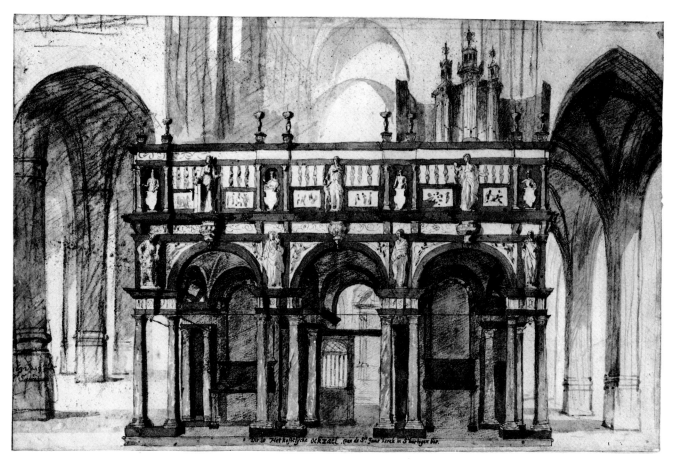

[27] INTERIOR OF ST MARY'S CHURCH, UTRECHT:
VIEW OF THE NAVE AND CHOIR

Pen and brown ink heightened with a little white, over black chalk;
39.3 × 29.6cm
Inscribed and dated by the artist: *S^{te} Marijenkerck, / binnen Utrecht / den 9 julij 1636*; and on the base of the column, bottom right: *P. Saenre . . .*

The 'eye-point' is indicated on the base of the column nearest the crossing, right. The drawings which Saenredam did of the churches in Utrecht during a visit in 1636 must be counted among his finest, and the present one is a fair example of their quality. Note the virtuosity in the handling of the black chalk and the range of tone expressed through its velvety surfaces. St Mary's was demolished in the nineteenth century, and the vivid sense of place conveyed by this and other drawings of it impart a heightened poignancy. The picture based on the Edinburgh drawing, painted in 1641, is now in the Rijksmuseum. Keith Andrews has observed that in this drawing Saenredam concentrates our attention on the Romanesque nave, while in the painting it is the Gothic choir beyond that is given prominence – a strange reversal of emphasis, considering that the picture was probably commissioned by Constantijn Huygens, who despised the Gothic style. The significance of the bull, whose hindquarters are visible near the base of the column on the left, is discussed by Gary Schwartz in his fine article in *Simiolus* (1), 1966 / 67, pp. 69–93.

Exh: Edinburgh, National Gallery of Scotland, *Old Master Drawings from the David Laing Bequest*, 1976, no. 74, fig. 23.
Ref: Utrecht, 1961, no. 149, pl. 150.

The National Galleries of Scotland

Follower of Pieter Saenredam

[28] INTERIOR OF A CHURCH, WITH AN ARTIST SKETCHING

Pen and ink, watercolour and body colour; 19 × 15.1cm
Inscribed on the base of the front pillar: *Pieter Saenredam A° 1630*; and below: *A. Borssom fecit*

The drawing was engraved by Ploos van Amstel, to whom it once belonged. A drawing possibly by the same hand (? Houckgeest or Van Vliet) was included in the Utrecht exhibition, 1961, no. 235, pl. 225.

Ref: A. M. Hind, *Catalogue of Drawings by Dutch and Flemish Artists . . . in the British Museum*, IV 1931, p. 46, no. 6.

The British Museum

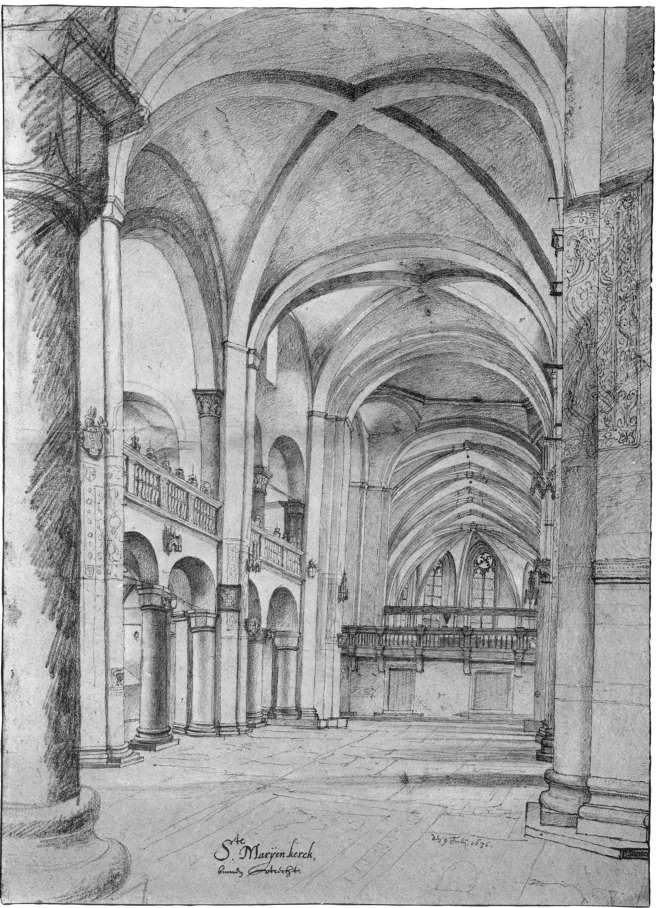

S.te Marijen kerck,
binnen Vtrecht.

d. 9 Iuly 1636.

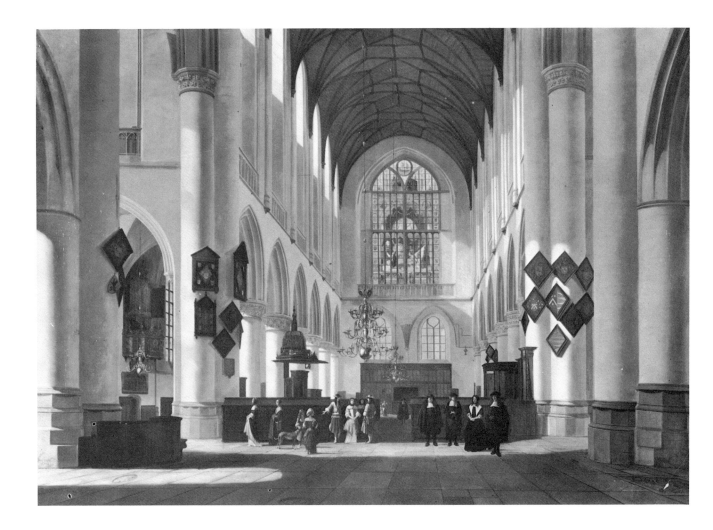

Job Berckheyde, 1630–1693

The elder brother of Gerrit Berckheyde. A painter of landscapes, genre pictures and portraits.

[29] INTERIOR OF ST BAVO'S: VIEW OF THE WEST END

Oil on canvas; 109 × 154.5cm
Signed and dated, on the base of the column, left: *J. Berckheyde / A°*
1668

This is a close-up view, taken beyond the crossing, of the west end of the church which is rather indistinct in the Edinburgh Saenredam. It is an important record of the great window which was covered up when the new organ was installed [fig. 17]. The subject of this window as represented by Berckheyde refers to the legend of Haarlem's part in the siege of Damiate, Egypt, during the Second Crusade. The scene depicts a figure kneeling before the Patriarch of Jerusalem, left, with the Emperor Frederick Barbarossa holding a sword in the centre. This window, to a design by Pieter de Grebber, replaced an earlier one showing George van Egmond (Bishop of

Utrecht, 1535–39) kneeling before the Trinity. Parts of the cartoon for this window are preserved in the Rijksmuseum (K. G. Boon, *Netherlandish Drawings of the Fifteenth and Sixteenth Centuries,* 1978, I, p. 135, no. 381; II, repr. p. 144). It is the earlier window which Saenredam reproduces in his two drawings of the church included here [18 and 22].

The exterior view of St Bavo's, placed under the organ on the left [fig. 16] and referred to in the discussion on the Edinburgh picture, is clearly discernible.

The hatchments ('rouwbord' or 'grafbord') attached to the columns of the nave, containing the arms of the recently deceased which are painted on a black background, were intended as temporary memorial tablets. They are a characteristic feature of the Dutch church interior, their potential as colour accents to relieve the plain expanses of bare wall used to great visual effect by many artists.

Frans Halsmuseum, Haarlem

[29a] detail of 29

50

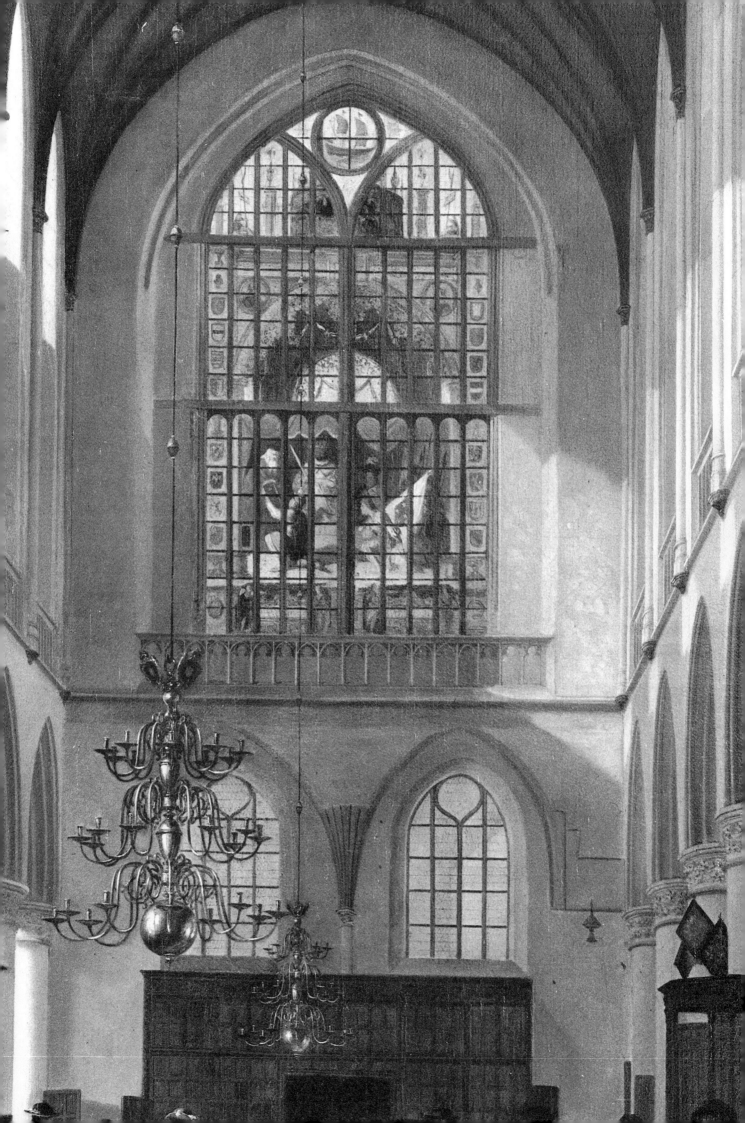

Gerrit Berckheyde, 1638–98

Born in Haarlem, and possibly a pupil of his brother Job. Together they visited Germany, and on their return to Haarlem lived in the same house. Gerrit painted a few landscapes and church interiors, but is best known for his town views.

[30] THE MARKET PLACE AND ST BAVO'S, HAARLEM

Oil on canvas; 51.8 × 67cm
Signed and dated lower right: *Gerrit Berck Heyde / 1674*

The view is from the north-west with the portico of the Town Hall, right. St Bavo's remains little changed today, although the stalls of the former fishmarket to the left of it have long since gone, and likewise the bell tower to the left of the church and beyond. Of the buildings on the right, only the Vleeshal (the former meat market), constructed by Lieven de Key, 1602 / 3, still stands. The houses on the north side of the church no longer exist. This is possibly the best of the many versions and variants that Gerrit Berckheyde painted of this view.

Ref: N. Maclaren, *National Gallery Catalogues. The Dutch School*, 1960, pp. 25–26, no. 1420.

The Trustees of the National Gallery, London

[Fig. 16] (?) Pieter Gerritsz, VIEW OF ST BAVO'S *c*.1518. Haarlem, St Bavo's (at present in store in the Frans Halsmuseum)

[30]

Isaac van Nickelen, active *c.* 1655; d. 1703

Lived and worked in Haarlem, where he was enrolled in the Guild of St Lüke, 1659. Many of his surviving pictures are of St Bavo's.

[31] INTERIOR OF ST BAVO'S:
VIEW OF THE NAVE AND CHOIR LOOKING EAST

Oil on canvas; 113 × 101.5cm
Signed and dated: *Isaac van Nickele 1692* (or 97)

It represents the opposite view to that seen in the Edinburgh Saenredam, with which it is instructive to compare. Van Nickelen's is the conventional nave view, but lacks Saenredam's sense of surface tension and pattern to counter the movement of the perspective, which has a disruptive effect. His picture is good topography but conveys nothing of the church's grandeur, which is the essence of Saenredam's sublime construction. Cleaned, 1984.

Exh: Utrecht, 1961, no. 240, pl. 231.

Frans Halsmuseum, Haarlem

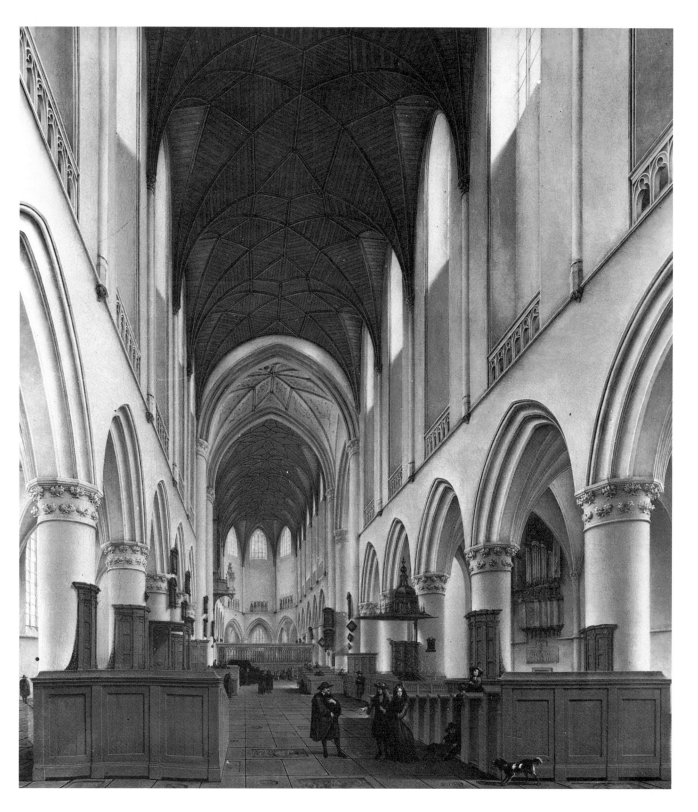

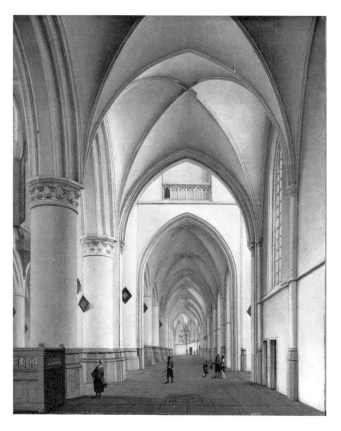

[32] INTERIOR OF ST BAVO'S:
VIEW FROM THE SOUTH AISLE LOOKING EAST

Oil on canvas, mounted on board: 57 × 48cm
Signed, lower left: *Isaac / van / Nickele*

Dated *c.* 1690 by P. Biesboer (to whom information on this picture
is due), and included in the sale of Johannes Enschede of Haarlem
(1786). The south ambulatory which is the subject of the Courtauld
Institute drawing [24] may be seen in the distance. Of all contem-
porary church painters, Van Nickelen was the one most obviously
influenced by Saenredam, as this picture clearly demonstrates.

Private Collection, Holland

Gerrit Houckgeest, *c.* 1600–61

Born in The Hague, and probably a pupil of Bartholomeus van
Bassen. In 1635 moved to Delft, where he joined the Guild of St
Luke in 1639. Visited England during the 1630s. At Stenbergen in
1652 and later settled at Bergen op Zoom, where he died.

[33] ARCHITECTURAL FANTASY WITH FIGURES

Oil on canvas; 131.1 × 152cm
Signed and dated, bottom right corner: *G Houckgeest fe 1638*

A painting in the Royal Collection is similar in composition and
must date from the same period (C. White, *The Dutch Pictures in
the Collection of Her Majesty The Queen*, 1982, p. 63, no. 88, pl.
77).

Exh: Utrecht, Centraal Museum, *Nederlandse Architectuurschil-
ders 1600–1900*, 1953, no. 49, fig. 22.
Ref: W. A. Liedtke, *Architectural Painting in Delft*, 1982, p. 31,
fig. 9.

The National Galleries of Scotland

[34] INTERIOR OF THE OLD CHURCH, DELFT (colour plate)

Oil on panel; 49 × 41cm
Signed on illusionistic frame below: G H

Dated 1651 by Liedtke. We know from pictures of Dutch domestic
interiors that paintings were hung with curtains in front of them, as
we see for example in the De Witte family group [fig. 3]. Houck-
geest, like other Dutch artists, of the period (for example Rem-
brandt, Vermeer, Dou and Steen) turned this practice to pictorial
effect by introducing it as an element of *trompe l'oeil*. The beauti-
fully painted green curtain in this picture has the effect of balancing
the recession on the left, but it has other implications too. 'The
painter is using a sophisticated and familiar pictorial artifice. The
picture within a picture that gains from its deceptive frame a
paradoxical and baffling kinship to reality is as old as the European
tradition itself' (L. Gowing, *Vermeer*, 1952, pp. 99–100).

Exh: Utrecht, Centraal Museum, *Nederlandse Architectuurschil-
ders 1600–1900*, 1953, no. 50, pl. 39.
Ref: W. A. Liedtke, *Architectural Painting in Delft*, 1982, p. 100,
no. 4, fig. 28.

Rijksmuseum, Amsterdam

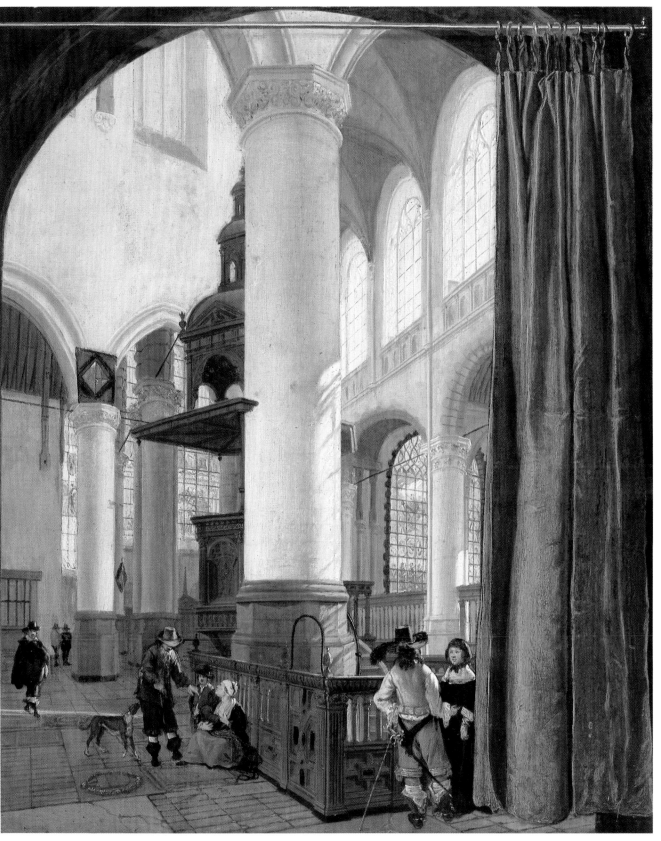

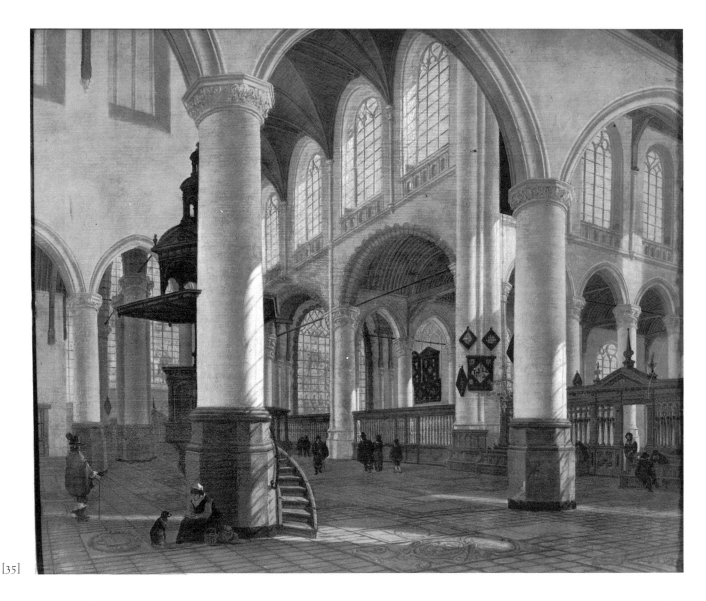

[35]

Emanuel de Witte, *c. 1617–92*

Born in Alkmaar. Lived briefly in Rotterdam before moving to Delft about 1641. Enrolled in the Guild of St Luke, 1642. Settled in Amsterdam, where he is first recorded in January 1652.

[35] VIEW OF THE OLD CHURCH, DELFT

Oil on panel; 41.9 × 56cm

The picture is first recorded in an MS list of the Montagu pictures, *c.* 1770, no. 111; and included in the old printed catalogue of the Montagu house pictures *c.* 1820, no. 232 (as Bleyswijck). De Witte's earliest dated church interior is the painting now in the Wallace Collection (1651), and this picture must be of about the same period.

Exh: London, British Institution 1818, no. 129; and 1829, no. 57.
Ref: *Catalogue of the pictures in Montagu House belonging to the Duke of Buccleuch,* 1898, p. 54, no. 168 (as Hoogstraten); I. Manke, *Emanuel de Witte 1617–1692,* 1963, p. 120, no. 198.

The Duke of Buccleuch and Queensberry, KT

[36] INTERIOR OF THE OLD CHURCH, AMSTERDAM

Oil on canvas; 79.1 × 63.1cm
Signed, lower left: *E de Witte*

c. 1660. The view is of the nave and south aisle, which the artist has altered slightly by including the small organ which was actually placed in the north aisle. The sermon was the most important part in the service of the Dutch Reformed Church and it is frequently the subject of De Witte's pictures. Dogs also appear frequently in his pictures, a reminder that there was the 'hondenslager' or 'dog-hitter' in the Reformed churches whose job it was to keep them out. (K. H. D. Haley, *The Dutch in the Seventeenth Century,* 1972, p. 90.)

Exh: Utrecht, Centraal Museum, *Nederlandse Architectuurschilders 1600–1900,* 1953, no. 114, pl. 37.
Ref: I. Manke, *Emanuel de Witte 1617–1692,* 1963, p. 89, no. 53, pl. 47; W. A. Liedtke, *Architectural Painting in Delft,* 1982, p. 126, pl. x.

The Trustees of the National Gallery, London

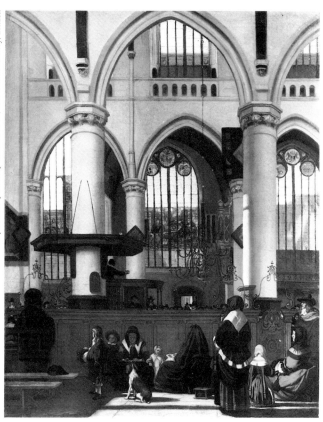

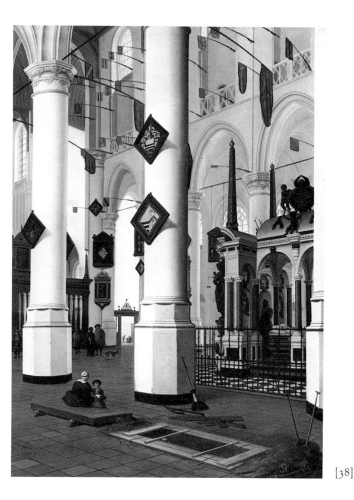

[36]

[38]

Hendrick van Vliet, *c.* 1611–75

[37] INTERIOR OF A PROTESTANT GOTHIC CHURCH

Oil on canvas; 190 × 162cm

c. 1680. This painting, the largest of De Witte's to have survived, is sadly in bad condition. It has suffered serious abrasion and also extensive losses of paint, which have been retouched. It is one of a series of imaginary interiors which incorporate elements from both the Old Church and New Church of Amsterdam. In general aspect this interior resembles the New Church, but the columns are from the Old Church, their capitals being an invention of the artist.

Exh: London, Royal Academy, *Dutch Pictures 1450–1750,* 1952/53, no. 272.
Ref: I. Manke, *Emanuel de Witte 1617–1692,* 1963 p. 105, no. 113, pl. 85.

The National Galleries of Scotland

The only artist mentioned by Van Bleyswijck in his account of Delft (1667), when Vermeer was still alive. Trained as a portrait painter and joined the Guild of St Luke, Delft, in 1632. Started painting church interiors about 1651/52. Recorded in Haarlem in 1654.

[38] INTERIOR OF THE NEW CHURCH, DELFT, WITH THE TOMB OF WILLIAM OF ORANGE

Oil on canvas; 127 × 85.5cm
A signature and date (*1667*) was read in 1962, but are now no longer visible.

William I (of Orange, or 'the Silent'), Father of the United Netherlands, was assassinated in Delft in 1584. His tomb by Hendrick de Keyser, erected about 1621 in the choir of the New Church (where also are buried his sons, Prince Maurice and Prince Frederick Henry) became a national shrine. It was the subject of particular veneration at the time of Prince William's death in 1650, and this interest is reflected in the numerous pictures of the tomb by Houckgeest, Van Vliet and others (A. K. Wheelock, *Simiolus* VIII, 1975/76, pp. 167–85).

Ref: *Walker Art Gallery, Liverpool. Foreign Catalogue,* 1977, p. 225; W. A. Liedtke, *Architectural Painting in Delft,* 1982, p. 109, no. 113, fig. 57.

The Liverpool Institute High School (on loan to the Walker Art Gallery)

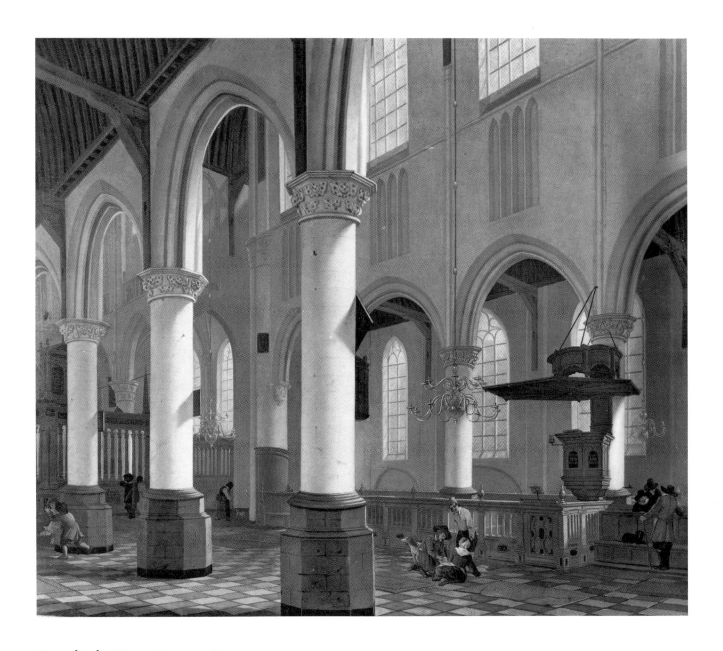

Cornelis de Man, 1621–1706

Lived in Delft. Best known for his portraits and genre scenes, but
also painted church interiors in the manner of Van Vliet. Enrolled
in the Guild of St Luke, Delft, 1642 – the year he set out on his
travels to Paris, Rome and Venice, from which he returned in 1653.

[39] INTERIOR OF THE NEW CHURCH, DELFT;
VIEW FROM THE NORTH AISLE LOOKING SOUTH-EAST

Oil on canvas; 68 × 81cm

Ref: W. A. Liedtke, *Architectural Painting in Delft*, 1982, p. 123,
no. 294, fig. 101.

The Trafalgar Galleries, London

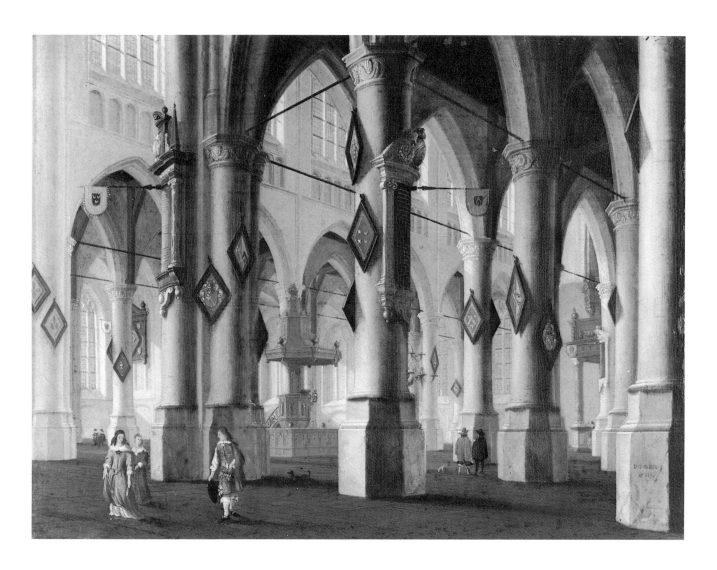

Daniel de Blieck, c. 1630–73

Born Middelburg where, in 1648, enrolled in the Guild of St Luke
as an architect. His pictures of church interiors depend heavily on
those of Van Vliet and De Lorme. He worked within the area of
Delft and Rotterdam, although a book of drawings after paintings
by De Blieck (Rijksdienst voor de Monumentenzorg, The Hague)
record a visit to England.

[40] INTERIOR OF AN IMAGINARY GOTHIC CHURCH

Oil on panel; 23.8 × 31.7cm
Signed and dated, bottom right: D. D. BLIECK. F./A° 1656

Previous reproductions include a running dog on the left and one
near the two figures on the right. These and other clumsy repaints
in the area of the floor of the church were removed during recent
cleaning (1984), which showed the picture to be in good condition.
It is based on Van Vliet's views of the Pieterskerk, Leiden, in the
Brunswick Gallery. The figures are rather coarse and are possibly
by another hand.

*Ref: Dutch and Flemish, Netherlandish and German Paintings in
the Glasgow Art Gallery* (catalogue by H. Miles), 1961, p. 26, no.
5, repr. p. 39 (as 'Interior of St. Laurenskerk at Rotterdam'); W. A.
Liedtke, *Architectural Painting in Delft*, 1982, p. 72, fig. 67.

Glasgow Art Gallery and Museum

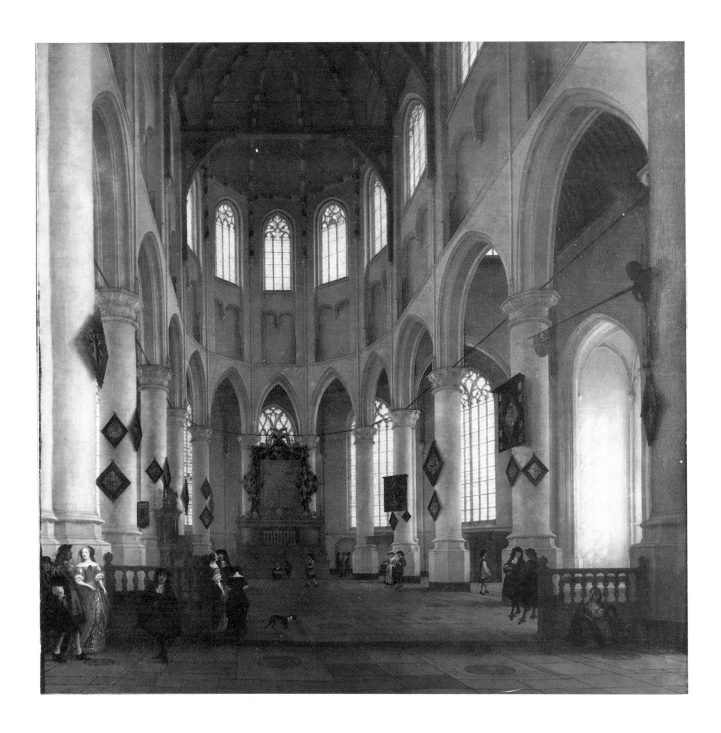

Anthonie de Lorme, *c.* 1610–73

Born Tournai. A painter of imaginary church interiors under the influence of Van Bassen until about 1652, when he started painting actual interiors, particularly of the Laurenskerk, Rotterdam – where he died.

[41] INTERIOR OF THE CHURCH OF ST LAURENS, ROTTERDAM

Oil on canvas; 114 × 114cm
Signed and dated lower left: A. DE. LORME. 1660

The way this interior is illuminated by the sunlight coming in through the windows on the right can be fully appreciated now that the picture has been cleaned (1983). The drawing of the architecture is most accomplished and the textures of the stonework beautifully realised.

Exh: London, Royal Academy, *Dutch Pictures 1450–1750,* 1952/53, no. 293.
Ref: G. Scharf, *Catalogue of the Collection of Pictures at Knowsley Hall,* 1875, p. 57, no. 107; H. Jantzen, *Das Niederländische Architekturbild,* 1910, p. 164, no. 223.

The Earl of Derby, MC

[Fig. 17] ST BAVO'S, HAARLEM; VIEW OF THE WEST END AND THE GREAT ORGAN. Photograph (*opposite*)

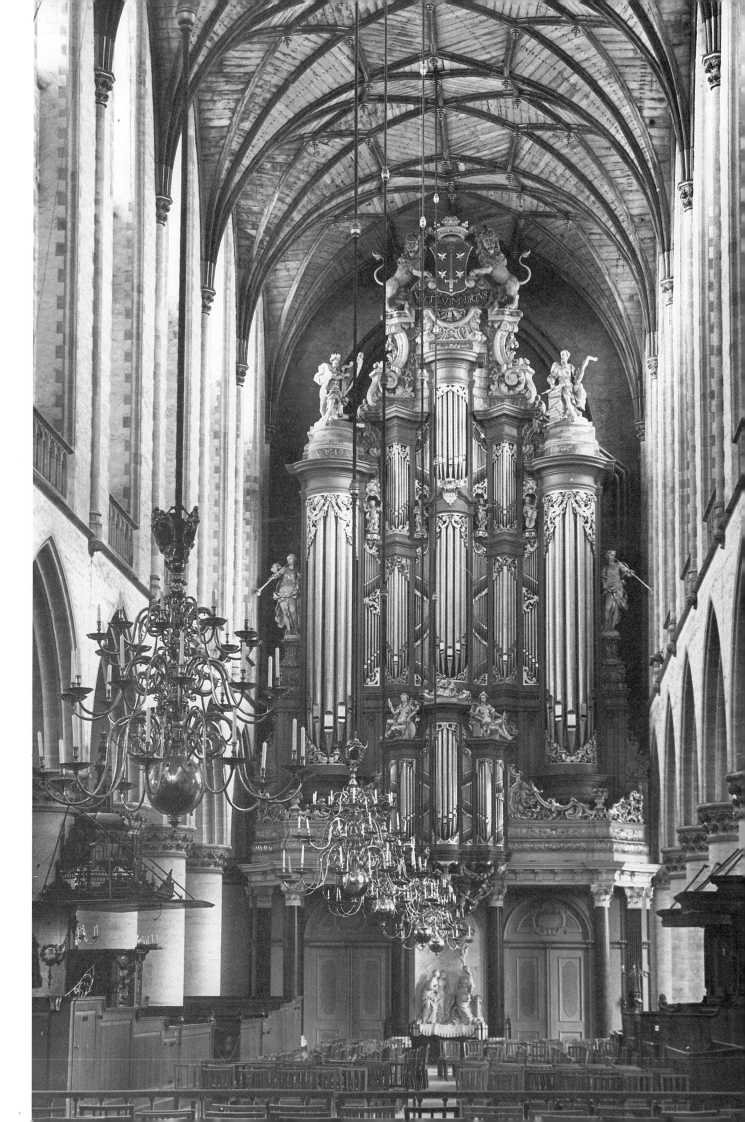

Bibliographical note

The classic book on the subject is H. Jantzen, *Das Niederlän-dische Architekturbild*, Leipzig, 1910 (2nd ed., 1979); while a complete bibliography may be found in W. A. Liedtke's *Architectural Painting in Delft* (Doornspijk, 1982). The basic and indispensable manual on Saenredam, incorporating information in P. T. A. Swillens's monograph (1935), is the *Catalogue Raisonné of the Works by Pieter Jansz. Saenredam*, published at the time of the exhibition at the Centraal Museum, Utrecht, 1961 (hereafter referred to as 'Utrecht, 1961'). Much of the present catalogue is based on this publication, from which are taken the English transla-tions of the inscriptions in Dutch on Saenredam's paintings and drawings. Additions to the Saenredam bibliography since the publication of the Utrecht catalogue and Liedtke include: S. Alpers, *The Art of Describing. Dutch Art in the Seventeenth Century*, 1983; and an article by her on the Edinburgh picture, 'Seeing and believing', *Art & Antiques* April 1984; E. J. Connell, 'The Romanization of the Gothic Arch in some paintings by Pieter Saenredam', *Rutgers Art Review I*, 1980, pp. 17–35; R. Ruurs, 'Drawing from na-ture', *La Prospettiva Rinascimentale*, 1980, pp. 511–21; and 'Pieter Saenredam: zijn boekenbezit en zijn relatie met de landmeter Pieter Wils', *Oud Holland*, 97, no. 2, 1983, pp. 59–68.

Index of artists

List of lenders

The Duke of Buccleuch and Queensberry, KT 35
The Earl of Derby, MC 41
The Marquis of Lothian 6

Anonymous loans 9, 10, 32
Amsterdam, Rijksmuseum 34
Edinburgh, National Galleries of Scotland 3, 11, 17, 27, 33, 37
Edinburgh, National Library of Scotland 2
Glasgow, Art Gallery and Museum 14, 23, 40
Glasgow, University of, Hunterian Art Gallery 12
Haarlem, Frans Halsmuseum 29, 31
Haarlem, Gemeentearchief 18, 19
Liverpool, Liverpool Institute 38
London, British Library 1, 8, 16
London, British Museum 15, 22, 25, 26, 28
London, Courtauld Institute Galleries 24
London, National Gallery 30, 36
London, The Trafalgar Galleries 4, 39
Maidstone, Museum and Art Gallery 5, 13
Paris, Fondation Custodia, Institut Néerlandais 21
Ritman: Joseph R. Ritman Collection 7
Woodner: Ian Woodner Family Collection 20